T0273062

Publisher:
Chin Music Press
2621 24th Ave W, Seattle, WA 98199, USA
www.chinmusicpress.com

Cover and book design by: Yusuke Shono
Printed in Canada by Imprimerie Gauvin
Library of Congress Cataloging-in-publication data is available.

First edition

CHIN MUSIC
P R E S S

L T F T

Spring 2014 Chin Music Press Seattle

LIZARD

TELEPATHY

FOX

TELEPATHY

by
YOSHINORI HENGUCHI

III.

IV.

The poems in *Lizard Telepathy Fox Telepathy* do not use standard capitalization or punctuation.
This is to preserve the usage of rhythm and register immediately present in the original.
The original works do not follow the standard rules of capitalization or punctuation either.
Lizard Telepathy Fox Telepathy is enjoyed best when read *aloud*.

Sometimes

I see dreams

of being overpowered

by a black panther.

At point-blank range, and at a distance of even a closer degree I hear folk songs of Nihon. I think about Nihongo. I think in Nihogo. Incidentally, we are Nihongo. I feel that Nihongo gulps down various elements, and in a sense, is a language formed by the matching of an "anything goes" positivity with unscrupulousness. Nihongo is a mutt with an unspecified social position. I want to feel the liberation that only a mutt can express. There is no rule that says that every bit of this and that is controlled. I want to savor completely a grammar in which there is no distance from my present feeling. And yet, whatever the case may be, it seems that Nihongo has been stolen. Probably not a case where they merely sucked on their fingers with envy and then ran away. A search for Nihongo that will not be undervalued too much, I reload. Twisted meanings and feelings of expression that cannot be ignored. I am aiming to smash through the sloth of grammar. I want to burn Nihongo and turn it into smoke. Going on thinking about this and that again and again is merely caprice. Nihongo for killing time. Nihongo where despite laughing all the time my eyes are set firmly. Electronically receiving half-opened Nihongo. Nihongo grips the heart with pangs of sadness. Taking out a hatchet and chopping Nihongo apart in a wild manner. Amplifying Nihongo. Nihongo of the same ilk as spontaneous wounds. Touching Nihongo with tongues and fingers. Do not demand manic depressive Nihongo. Try bulldozing down "thoughtless Nihongo, actionless Nihongo." Don't you fucking think about closing Nihongo away in a funeral urn. Nihongo that ties your stomach in a knot is just soooo *cute*. Nihongo that rips away

common sense with malicious intent and "omissions?" Should we freeze Nihongo in a block of ice? Transferring emotions into Nihongo that is missing something. Through delusion and a simplistic self-consciousness Nihongo experienced incontinence. Nihongo, hollow and smashed. Nihongo with handsome scales. Kicking it around, rough Nihongo, making it even rougher. I took apart the belly of Nihongo that reeked of fish, stuck a finger in it, removed the intestines and washed it with water. Nihongo exhausted with nostalgia so deep it's brutal. I am going to use some alcoholic and therefore outrageous Nihongo and see what happens. Nihongo was split with a hammer. All around, as far as the eye can see, the outline of Nihongo is breaking down. Household appliances and Nihongo are being blown away by the wind. On clear days I go to see Nihongo sprout. I want to be sucked dry while viewing sharp Nihongo. Nihongo that looks for something above and beyond being sharp. Nihongo is strong for no reason at all. Nihongo is being hated and thanked. Nihongo that cannot continue to try due to a lack of sleep. Sobbing dearly for Nihongo that is rotten to the core. Gliding Nihongo. Indoor Nihongo plays dead when it lets itself go. Nihongo made on purpose to break easily. Some rather illegal Nihongo is decorating the room. Nihongo that isn't afraid of dying in an accident. I'll adopt Nihongo that is really good at making people feel better. Lukewarm Nihongo is merely pushy. Hey, I'll arrange for some Nihongo that looks like it would be an easy lay for you. Feeling sad for Nihongo that goes insane bit by bit is annoying. Nihongo that has an appointment. Nihongo with a giant red ribbon tied to it in the middle

of the night sky. Nihongo is flooding in all sorts of skills. Executed-one-after-another Nihongo stood out. Nihongo that is rich with feeling, sensitivity, surrounded by what is known as Jōmon pottery, enlightened to something akin to a spiritual awakening. From now on how will you carry on with Nihongo? The gaiety of Nihongo filled with lament. Your Nihongo is not the least bit different from my nightmares. Nihongo manipulated into existence is welcoming meaninglessness. The Nihongo of the past has completely ended. And the Nihongo of the future has even yet to begin. Nihongo carried in by a thousand carrier pigeons. Which one of you is the Nihongo with canary colors? Every once in a while I try to chase Nihongo in circles at breakneck speed. Nihongo that was brought up surrounded by flowers is somewhat arbitrary. Dishonest Nihongo always walked around carrying a cow's tongue in its pocket. I am going to take a taxi to see fireball Nihongo. Nitroglycerine-like twins were trying to chop down Nihongo with an ax. Even lethargic Nihongo cannot be too bad? Nihongo that lines up is prey for bears. Nihongo lacking in vitality depressingly failed to be picturesque. Only the shadow of mysterious Nihongo will grow longer. Nihongo tired of raising children became annoyed. It would have been just fine to look at the frightening Nihongo in the space between your fingers. Yay, Nihongo really is coldhearted. The value of Nihongo will be decided by fate. What was that? Something smells as if it is burning. Smoke from something not of small concern has completely filled the room. It was probably the room next door, burning. Anyway, the person in

the next room probably wants to burn Nihongo and turn it all into smoke, too. Sometimes it is the case that Nihongo easily dies off. Never seen-or-heard-of Nihongo dies quite easily with blood dripping from its nose, offed by the mere extent of a direct hit in the back of the head by a swallow with a case of ADD. Sometimes, Nihongo does not just drop dead easily. Even if hit by an armored car, Nihongo that is a complete stranger no matter what lands absolutely brilliantly and immediately inhales all the nectar of the flowers everywhere and does not drop dead so easily. Shy Nihongo will chop your legs in half and suck your blood dry. Nasty Nihongo never goes wild. Nihongo hopelessly grips and squashes horse sashimi flat. A somehow-conservative clothes dryer and Nihongo are being skewered into *kushisashi*. That thing called Nihongo is in the end just Nihongo. And despite this, I hope to fool around with Nihongo that is Nihongo from head to tail. Nihongo that will not make me feel uneasy as much as it might. Well, Nihongo just seemed very busy roasting calamari. Nihongo is always Nihongo, and while probably today's Nihongo rather than yesterday's Nihongo, more than today's Nihongo tomorrow's Nihongo will likely be so determined that it will disgust. Those of us doing whatever Nihongo says have the same bone structure. Nihongo may already be an illusion. All spoken Nihongo has the possibility of being music. I want to numb all the overabundant, boring Nihongo. Nihongo that is absolutely crazy is absolutely love. Nihongo is something like a castle, and I always go out after I take that castle and screw it into the back of my ear. Nihongo reigns over everyone's retinas. Nihongo is clay. One must not forget the

fact that there exists Nihongo of an absolutely ridiculous disposition. Go follow the trail of blood dripping from Nihongo. I want to melt into the Nihongo of inertia. I'm going to store some Nihongo in a gunpowder warehouse. I can't remove the odor of Nihongo stuck to my middle and index fingers. Nihongo is the environment wrapped around us. If you don't want to look at that Nihongo flush it down the toilet. To be brief, an old friend of mine threw up from being too angry at my Nihongo. Lazy Nihongo lost even the money to live and is like an empty shell. I'm going to fill my empty stomach with compelling, wall-of-dreams Nihongo. Nihongo that even when broken does not make one feel the need to fix it. Or, Nihongo patched up with an adhesive and such. Nihongo from inception to annihilation. My blood trills with passion for tenderly cared for Nihongo. Enticed even by disheveled wafer-thin Nihongo. Splitting-apart and sticking-together Nihongo looks busy. All too soon Nihongo is seen-through and deteriorating. Nihongo recovers half-heartedly. Nihongo that will do its own cooking even out of stubbornness. Absolutely unable to run away late Nihongo. Sideways Nihongo. Back Nihongo. Please do not throw away so-over-the-top-that-it-makes-it-hard-to-breathe Nihongo. Who is the Nihongo that clears the mind through and through? I have something for ridiculous Nihongo to do. I am going to boil Nihongo in an iron kettle. The wah-wah pedal shorted out, did Nihongo come all this way and die from electrocution? Who is evacuation-shelter Nihongo? Who is the unreligious Nihongo without even an altar and without any need to burn an offering of incense? Who is the Nihongo that will not

allow stagnation? Who is the take-off-and-burst-into-flames Nihongo? Who is the plotting-a-deviation-from-the-program Nihongo? Who is out-in-the-open-obscene Nihongo? We are all the descendants of Nihongo. Taking Nihongo and forcing it to molt. Pregnant Nihongo goes berserk. Meta-Nihongo. Who is tearing-away-the-image-of-happy-family-life Nihongo? Murderous superficially happy Nihongo is progressing. Who is bloodshed-inducing Nihongo? In any case, it is clearly Nihongo. Who is pleasure-device Nihongo? Who is smells-like-the-core-of-a-pencil Nihongo? Who is gives-others-their-due-respect Nihongo? Crumpled, twisted and stretched, Nihongo is being raped. Who is wrapped-in-a-tissue, being-torn-to-shreds-by-hedonism-and-the-seniority-system Nihongo? Familiar Nihongo is gravity. Mixed-public-and-private Nihongo is skin sensation. Who is wants-to-stop-but-can't Nihongo? Who is in-the-future-will-be-completely-squashed Nihongo? Please guess as to what that Nihongo is. Nihongo that could see too much from the veranda had a compound fracture. For Nihongo there is both a time to live and a time to die. Nihongo will not become a soldier. My frontal cortex will become completely buried by Nihongo. Who is the Nihongo still entwined together in bed? Fever-stricken Nihongo will chop off the heads of fighting bulls one after another. Nihongo stays out all night without permission rather often. Who is the Nihongo that evaporates from the eyes of society? Who is the Nihongo that attenuates from acts of terrorism? Who is the Nihongo of the tension above? Nihongo does not even want to be saved. As if to trace the coastline our Nihongo will produce a liberating fall. Who

is the Nihongo who tells amateurs to fuck off? The thing is, for the time being we must lay out all the Nihongo. Involved with Nihongo. Involving Nihongo. Who is the remix Nihongo with smell and color transposed? Who is the Nihongo who does not retaliate and will not allow retaliation? Who is the Nihongo discharging jolts of electricity? Who is the joy of Nihongo that invites people to misunderstand? Who is the Nihongo who, after loud and glaring drunken revelry, acts meaninglessly savage? The cut of the guillotine and the like, who is the Nihongo with such an angle? Who is the pleasure of Nihongo that does not release its tension? Who is the pleasure of Nihongo that looks at an abstract painting and wrings out its title? Who is the pleasure of cracked or deformed Nihongo? Who is the Nihongo resembling a psychotic salamander? Who is the Nihongo gathering electric light called electric light and dazzled? Who is the Nihongo like plunder and reminiscence? Who is the listening-in-sniffing-out Nihongo? Who is the Nihongo who went mad five thousand times and had six thousand epiphanies? Who is the Nihongo who went mad six thousand times and had seven thousand epiphanies? Who is the Nihongo who went mad eight thousand times and had nine thousand epiphanies? At this point I would like to start a torn-into-tatters, rough, grainy Nihongo. I would like to start a Nihongo that arrives. I would like to start a Nihongo that is going to make a mess of things. I would like to start a self-employed Nihongo that grasps hands and joins forces.

I would like to start a Nihongo that is precise in its ruthlessness. I would like to start a Nihongo that plucks out the backs of eardrums without a

second thought. I would like to start a Nihongo that thoroughly spoofs reality. I would like to start a Nihongo that does not possess. I would like to start a Nihongo that cannot be possessed. I would like to start a Nihongo for which intimidation is not its sole talent. I would like to start a Nihongo that obliterates our bad luck and mannerisms with enormous sobriety. I would like to start a Nihongo that will absolutely not be slighted. I would like to start a Nihongo that will not make others want to slight it. I would like to start a Nihongo that does not destroy promises. I would like to start a Nihongo that receives applause even in pure darkness. I would like to start a Nihongo that receives applause even in absolute darkness.

時々黒豹に

征服される

夢をみる。

至近距離で、いちだんと至近距離で日本の民謡を聴く。日本語を考える。日本語で考える。私達はたまたま日本語である。日本語は色々な要素を飲み込んでいて、ある意味 "何でもあり" というポジティブと無節操とが合致している言語だと思う。日本語は身分不明の雑種である。雑種だけが持つ解放感に触れたりしたい。何でもかんでも管理されるいわれはない。今の気分とズレのない文法を満喫したい。それにしても日本語は奪われてるみたいだ。ただただ指をくわえて奪われている場合ではないだろう。過小評価されない日本語の検索、更新。尖ってて無視できない語感や意味。文法の倦怠感を突破したいと思っている。日本語を燃やして煙にしてしまいたいと思っている。あれやこれや思い回すのは勝手だろうと考えている。暇つぶしの日本語。いつも笑っているのに目が据わっている日本語。半開きの日本語を受信する。キュンキュンの日本語。ナタをふりかざして日本語を鮮やかに切断させる。増幅する日本語。かまいたちと同類の日本語。指と舌で日本語に触る。ソウ状態の日本語を強要するなよ。"考えない日本語、行動しない日本語" を張り倒してみる。日本語を骨壺なんかに閉じ込めるんじゃないぞ。腹をくくった日本語って超カワイイ。悪意と "抜け" でもって常識などをハクダツする日本語は？ 日本語を氷りづけにしちゃう？ 何か欠けている日本語に感情移入する。短絡的な自意識と妄想で日本語は失禁したんだ。ペッタンドッシャンの日本語。うろこがカッコいい日本語。がさつな日本語を蹴散らかして、も

っとがさつにする。魚臭かった日本語の腹を裂き、指突っ込んで腸を出して水で洗った。えげつないほどのノスタルジーにへとへとになった日本語。アルコール中毒ゆえの突飛な日本語を活用してみる。日本語がカナヅチで割られていた。辺り一面、日本語の輪郭が崩壊してる。家電製品と日本語が風に飛ばされる。晴れた日に日本語の芽吹きを見に行く。鋭利な日本語を眺めたままで干からびてしまいたい。鋭利の更に上を目指す日本語。日本語は訳もなく強い。日本語が嫌われたり感謝されたり。睡眠不足で頑張れない日本語。根っからダメな日本語に号泣する。ぬめっている日本語。インドア系の日本語は気を許すと死んだフリをするんだ。わざと壊れやすいように作られた日本語。かなりイリーガルな日本語を部屋に飾っている。事故死を恐れない日本語。慰めがうまい日本語を養子にもらう。ヌルい日本語はウットウしいだけ。すぐヤレそうな日本語を手配してあげる。ちょっとずつ発狂してる日本語を悲しむのは面倒くさい。アポのある日本語。巨大な赤色のリボンを結ばれた日本語が夜の空に。あらゆるスキルで日本語が氾濫している。次々と処刑されている日本語が目立っていた。感性の豊かな日本語が、いわゆる縄文式土器に囲まれながら悟りらしきものを啓いた。これから日本語とどうする？　悲哀に満ちた日本語の華やかさ。君の日本語は私の悪夢と少しも違わない。練り上げられた日本語は無意味を歓迎している。過去の日本語は終わってしまった。未来の日本語は始まってもいない。千羽の伝書鳩を引き連れた日

本語。カナリア色の日本語は誰だろう？　時には日本語を猛スピードで追い回してみる。花に囲まれて育った日本語はちょっと独断的。誠実でない日本語はいつもポケットの中に牛の舌を持ち歩いていた。火だるまの日本語をタクシーで見に行く。ニトログリセリンみたいな双子が斧で日本語を切り倒そうとしていた。無気力な日本語だって別に悪くないだろう？　行列に並ぶ日本語がクマの餌食。生命力に欠けてる日本語はゼツボー的に絵にならなかった。得体の知れない日本語の影だけが長く伸びる。育児疲れで日本語がイラ立っていた。怖い日本語は指と指の隙間から見ればいいんだった。イエイ、日本語ってやっぱり冷淡だね。日本語の価値は運が決める。

ん？　何かコゲ臭い。ただ事ではない煙が部屋中を満たしている。多分隣の部屋が燃えているんだろう。どうせ隣人も日本語を燃やして煙にしてしまいたいのだろう。例えば日本語は簡単にくたばったりする。注意散漫なツバメが後頭部に直撃したぐらいで、鼻血ドボドボと垂らしながら見ず知らずの日本語が簡単にくたばったりする。例えば日本語はそう簡単にくたばったりしない。装甲車にハネ飛ばされても、すごく見事に着地するや否やそこらじゅうにある花の蜜を吸い尽くして何が何でも赤の他人の日本語はそう簡単にくたばったりしない。人見知りの日本語はお前の脚をちょん切って血を吸うぞ。ヤな日本語とは羽目を外さない。どうしようもなく馬肉の刺身を握り潰してしまう日本語。どこかしら保守的な衣

服乾燥機と日本語が槍で串刺しにされている。日本語なんて結局のところ日本語でしかないんでしょ。それでも徹頭徹尾日本語とじゃれ合いたいな。それなりに白けさせない日本語。ええと、日本語はスルメイカ焼くのに忙しそうだった。日本語はいつも日本語で、昨日の日本語より今日の日本語なんだろうけど、明日の日本語は今日の日本語よりもウンザリするぐらい確固たる日本語なんでしょうね。日本語に言いなりの私達は同じ骨格をしている。もう日本語は幻想なのかもしれません。口にする日本語の全部は音楽になる可能性がある。有り余る退屈の日本語を麻痺させたい。絶対に、頭イカレてる日本語は愛である。日本語はお城みたいなもので、私はいつもそのお城を耳の奥に捻じ込んでから出掛けるのだ。皆の網膜には日本語が君臨してる。日本語は粘土。なんだか途方もない性癖の日本語が存在しているんだっていうことを忘れてはいけません。日本語が漏らした血の跡をたどって行け。惰性の日本語にとろけたい。火薬庫に日本語を寝かして置く。中指と人差し指に日本語の匂いがこびり付いて剥がれない。日本語は私たちを取り巻く環境。見たくないんだったら日本語なんてトイレに流してしまいなさい。早い話、私の旧友は私の日本語に腹を立てすぎて嘔吐したのだった。怠惰な日本語は生活費すら無くなっちゃって抜け殻の様だ。切実な夢想壁の日本語で空腹を満たしてみる。壊れても直す必要を感じさせない日本語。又は接着剤等で補修された日本語。発生から消滅までの日本語。手塩にかけられた日本

語に血が騒いだ。ダラしなく薄っぺらい日本語にもソソられる。別れたりくっ付いたり日本語は忙しそうだ。程なくして日本語は見え透いて衰弱している。日本語はいい加減に回復する。意地でも自炊する日本語。必ず逃げ遅れない日本語。横日本語。裏日本語。度を越して胸苦しい日本語を棄てないで下さい。頭が冴え渡る日本語は誰でしょう？ 無茶な日本語に用がある。鉄釜で日本語を沸かしてみる。ワウペダルがショートして、ここにきて日本語が感電死？ 避難所としての日本語は誰でしょう？ 無宗教で祭壇もなく焼香もいらない日本語は誰でしょう？ 停滞を許さない日本語は誰でしょう？ 片っぱしから離陸炎上する日本語は誰でしょう？ プログラムからの逸脱を図る日本語は誰でしょう？ 公然とワイ雑な日本語は誰でしょう？　私達は日本語の子孫である。無理矢理日本語を脱皮させる。妊娠した日本語は凶暴になる。メタ日本語。一家団らんを剥奪する日本語は誰でしょう？ 殺人的な空元気で日本語が行進している。流血を伴う日本語は誰でしょう？ とに角、確かに日本語である。娯楽装置としての日本語は誰でしょう？ エンピツの芯の匂いがする日本語は誰でしょう？ 一目置ける日本語は誰でしょう？ 丸め、捻じり、延ばされ、日本語は犯されている。快楽主義と年功序列に引きちぎられてティッシュに包まれた日本語は誰でしょう？ 身近な日本語は引力。公私混同の日本語は皮膚感覚。止むに止まれぬ日本語は誰でしょう？ 将来的には完璧に踏み潰されてしまう日本語は誰でしょう？ そ

んな日本語を察してやって下さい。ベランダから見えすぎて
いた日本語が複雑骨折していました。日本語には死ぬ時と生
きる時がある。日本語は兵隊にはならない。前頭葉が日本語
で埋め尽くされていく。ベッドの上で絡み合ったままの日本
語は誰でしょう？ 熱を帯びた日本語が闘牛の首を次々に刎
ねていく。ヤタラと日本語は無断外泊する。世間の尺度から
蒸発する日本語は誰でしょう？ テロでヤセる日本語は誰で
しょう？ 上のテンションの日本語は誰でしょう？ 日本語は
いつまでも救済されたくもない。沿岸をなぞるように私達の
日本語は開放的な墜落を遂げるのだ。シロートはすっこん
でろ系の日本語は誰でしょう？ とりあえず日本語を出し切
るっていうこと。日本語に関与する。日本語に関与させる。
色と匂いを置き換えたREMIXの日本語は誰でしょう？ 報復
しない報復させない日本語は誰でしょう？ ガバガバに放電
している日本語は誰でしょう？ 人の誤解を招く日本語の楽
しさは誰でしょう？ ドンチャンドンチャランと騒ぎ倒した
後、無意味に殺伐とする日本語は誰でしょう？ ギロチンの
切れ味とか、あの角度の日本語は誰でしょう？ 緊張感を放
棄しない日本語の楽しさは誰でしょう？ 抽象画を見て、そ
の題名を捻り出す日本語の楽しさは誰でしょう？ ひび割れ
や変形した日本語の楽しさは誰でしょう？ 錯乱したサンシ
ョウウオと類似した日本語は誰でしょう？ 電光という電光
を集めて目がくらむ日本語は誰でしょう？ 略奪や回想みた
いな日本語は誰でしょう？ 耳を傾ける鼻を利かす日本語は

誰でしょう？ 五千回血迷って六千回ひらめいた日本語は誰でしょう？ 六千回血迷って七千回ひらめいた日本語は誰でしょう？ 七千回血迷って八千回ひらめいた日本語は誰でしょう？ 八千回血迷って九千回ひらめいた日本語は誰でしょう？ 何かズタズタに粒子の荒い日本語を始めたいと思っている。くる日本語を始めたいと思っている。ヤラかす日本語を始めたいと思っている。手と手を取り合って自営する日本語を始めたいと思っている。

無慈悲さゆえに精密な日本語を始めたいと思っている。鼓膜の奥をそこはかとなく掻き毟る日本語を始めたいと思っている。非常に茶化す日本語を始めたいと思っている。所有しない日本語を始めたいと思っている。所有されない日本語を始めたいと思っている。脅すだけが能じゃない日本語を始めたいと思っている。膨大な地道さでもって私達のマンネリや不運を粉砕にする日本語を始めたいと思っている。絶対に軽視されない日本語を始めたいと思っている。絶対に軽視させない日本語を始めたいと思っている。約束を滅ぼさない日本語を始めたいと思っている。真ッ暗闇でも拍手される日本語を始めたいと思っている。完全な暗闇でも拍手される日本語を始めたいと思っている。

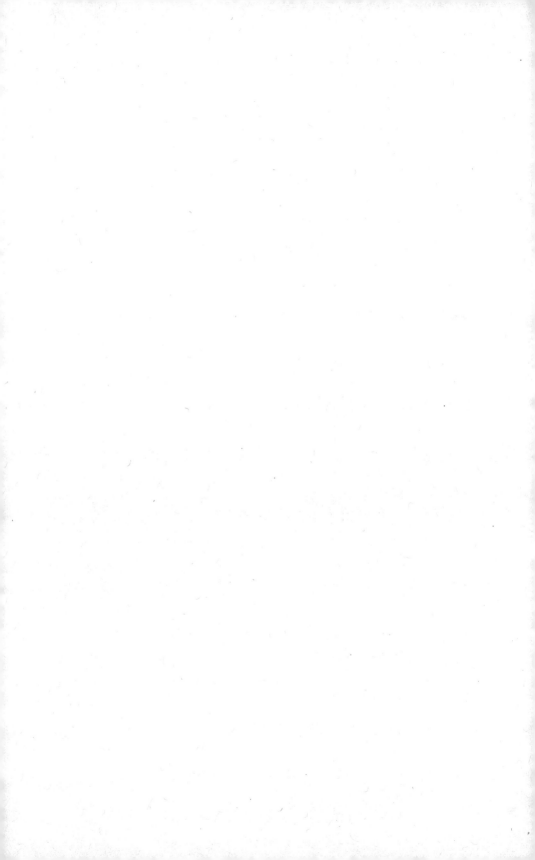

FOR DAD

忍ぶ忍ぶその身は

Panasonic

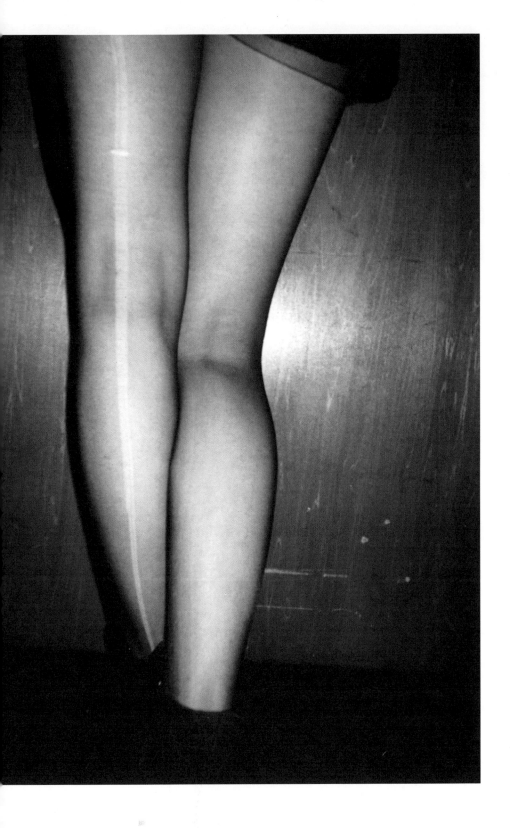

I.

The Tea Room

I am cold-blooded. My sister is rather cold-blooded. When both
of these cold bloods are mixed together, a fire ignites.
It must be dark around the periphery to start.
The fire lives by consuming darkness.
That which is called fire is a strange brutality.
That which is called fire is a sad excitement.
My sister looked at the fire as though she were testing it.
I am going out in order to avoid the heat. I might be gone for
two, three days

茶室

私は冷血です。姉はわりあいと冷血です。その両方
の冷血を混ぜると発火します。

周辺は闇でないといけない。

火は闇を食べて生きています。

火というのは不思議なさつばつさである。

火というのは悲しい興奮なのです。

姉は試すような目で火を見ていました。

私は避暑に出掛けます。二、三日　留守にするかも
しれません

０歳

０歳から始める「視覚のうねり」

１歳から始める「ペラペラの世界」

２歳から始める「机にどっかり大あぐら」

３歳から始める「スイミング」

４歳から始める「思い上がり」

５歳から始める「つきつめたピロトーク」

６歳から始める「アブノーマル」

７歳から始める「実感」

８歳から始める「直感」

９歳から始める「ソフトな存在」

Zero Years Old

From year 0 begins "the wave of eyesight"

From year 1 begins "the world of fluent speech"

From year 2 begins "sitting at a desk with legs crossed wide"

From year 3 begins "*swimming*"

From year 4 begins "conceit"

From year 5 begins "thought through pillow talk"

From year 6 begins "abnormality"

From year 7 begins "realization"

From year 8 begins "intuition"

From year 9 begins "a soft existence"

Sunday Memory

My Sunday memories begin at about age four; they begin with a voice that spoke in staccato and a bow tie. The first floor of our two-story building made its living from bow ties; the second floor subsisted on false eyelashes. The bow ties strewn about the *washitsu* room had something about them that caught attention, and I would put them in my mouth and try to draw them. No matter what I did, I could never draw that somehow secret relationship between the *washitsu* and the bow ties as I desired. My drawings were too elegant. I was at the point where if I had gone just a bit further I might have destroyed their relationship. Even so, I enjoyed drawing the pictures in my own way. I would also sometimes spend the entire afternoon running around and drawing pictures. The records my father played were always pleasurable. I would become unaware of whether I was drawing pictures or dancing, and in some way I was overwhelmed by my own blindness.

"Until we've had enough of it let's talk" chimed the record over and over. My father dressed up and spun the record. Scratching the record recklessly with a face filled with satisfaction he picked up the turntables and turned them over, piled them on and rolled them around. Each time he did so, the record would become a very friendly thundering noise and, more than music to me, it felt as if it were a radical abstract painting.

Hello

I received a bouquet from an old friend. I have no idea what type of flowers they were. A bouquet with unusual silver petals. It was a bouquet pulsating to the point where you took notice of it, for better or for worse, a bouquet that was just too much. What were they thinking with this bouquet? I wanted to show it off to somebody and, just as it was, I took it with me and went outside. A woman passing by plucked away a silver petal as though she could not help it and said "goodbye" to me. An old man passing by plucked away a silver petal as though he could not help it and said "goodbye" to me. My father passing by plucked away a silver petal as though he could not help it and said "goodbye" to me. My mother passing by plucked away a silver petal as though she could not help it and said "goodbye" to me.

Sumi-chan passing by plucked away a silver petal as though he could not help it and said "goodbye" to me. Takeo passing by plucked away a silver petal as though he could not help it and said "goodbye" to me. Many others passing by plucked away silver petals as though they could not help it and said "goodbye" to me. At some point, in my eardrums "goodbye" set in. My old friend passing by plucked away a silver petal as though he could not help it and said "goodbye" to me. There were many things that I wanted to say but "goodbye" and "thank you" were all I could say.

日曜日の記憶

日曜日の記憶は４才の頃、スタッカート気味に話し掛ける声と蝶ネクタイから始まっている。二階建ての一階は蝶ネクタイで生計が立てられ、つけ睫毛で二階が成り立っていた。和室に散らかる蝶ネクタイは興味を引くところがあって僕は口に含んだり絵に描こうとした。和室と蝶ネクタイの何かしら親密な関係はどうしても思うように描くことができなかった。僕の絵はすんなりしすぎていて。もう少しで彼らの関係を台無しにするところだった。それでも絵を描くことは自分なりに楽しんでいた。昼の間中ずっと走り回って絵を描いたこともあった。父親のかけるレコードはいつも軽快で。絵を描いていたのか踊っているのかわからなくなって、自分の闇雲さに何かと圧倒されていた。

"飽きるまで　話そうよ" とレコードが鳴りつづいていた。父親は正装してレコードを回した。無謀なスクラッチをして満足気な顔をしたり　ターンテーブルを持ち上げては反転させ積み重ねて転げまわった。そのたびにレコードは友好的な轟音になって音楽というより僕には過激な抽象画みたいに感じられた。

こんにちは

昔の友だちから花束が届いた。何の花なのかはわからない。見慣れない銀色の花びらをつけた花束だった。見て取れるほど脈打っている花束でよくもわるくも目に余る花束だ。なにを思ってこんな花束なのか？

　わたしは誰かに見せびらかしたくなってそのまま花束を連れて外へ出かけた。すれ違う女の子が申し訳なさそうに銀色の花びらを一枚引き抜いて「さようなら」をわたしに言った。すれ違うおじさんが申し訳なさそうに銀色の花びらを一枚引き抜いて「さようなら」をわたしに言った。すれ違う父親が申し訳なさそうに銀色の花びらを一枚引き抜いて「さようなら」をわたしに言った。すれ違う母親が申し訳なさそうに銀色の花びらを一枚引き抜いて「さようなら」をわたしに言った。

すれ違う住ちゃんが申し訳なさそうに銀色の花びらを一枚引き抜いて「さようなら」をわたしに言った。すれ違う丈雄が申し訳なさそうに銀色の花びらを一枚引き抜いて「さようなら」をわたしに言った。すれ違うその他もろもろが申し訳なさそうに銀色の花びらを一枚引き抜いて「さようなら」をわたしに言った。いつの間に、わたしの鼓膜に「さようなら」が定着していた。すれ違う昔の友だちが申し訳なさそうに銀色の花びらを一枚引き抜いて「さようなら」をわたしに言った。わたしはいろいろと言いたいことがあったけど「さようなら」と「ありがとう」としか言うことがなかった。

Caterwaul

The cat is wailing out in stifling tormented heat

That which is a cat can be said to possess a unique brutality

I think it is a very serene brutality

Moving on, I began to feel tired just a moment ago

Have I gone insane?

The mind of a person easily breaks down

and that was deeply emotional

After dinner I clapped my hands in applause

A Convenient Armageddon

Anyhow this shaved ice tastes like mouthwash.

My bride wearing a pure white kimono was also eating shaved ice.

She ate it with a *uselessly* solemn expression.

"You know, your face is like a degraded copy,"

she said while eating the shaved ice.

Anyhow she had a voice that could break glass.

"Of course my face has always been a degraded copy,"

a copy of a copy of a copy of a copy of a copy of a copy of a copy of a

copy of a copy of a copy of a copy of a copy of a copy of a copy of a

copy of a copy of a copy of a copy of a copy of a copy of a copy of a

copy of a copy of a copy.

Looked at for a brief while and afterwards thrown away.

"Unexpectedly cold summer Sundays are glaringly obvious,"

I said while eating shaved ice.

And then some part of me had frozen to death.

猫が暑苦しく鳴ってる

猫とは一種独特の殺伐さがある

よくよく長閑な殺伐やと思う

それはさて置いてさっきからだるい

何か頭おかしくなった？

人の頭は結構すぐに壊れる

それはすごく感動的だった

夕飯が済んでから拍手した

手頃な終末

なんにせよ口内洗浄液みたいなカキ氷である。
白無垢を着た花嫁もカキ氷を食っていた。
ムダに神妙な顔で食っている。

「ところであなたの顔は劣化コピーのようね」
カキ氷を食いながら花嫁は言った。
なんにせよガラスが割れるような声である。

「もちろんいつだって私の顔は劣化コピーである」
コピーのコピーのコピーのコピーのコピーのコピーのコ
ピーのコピーのコピーのコピーのコピーのコピーのコピー
のコピーのコピーのコピーのコピーのコピーのコピーのコ
ピーのコピーのコピーのコピーのコピーの。
少しの間だけ見詰められて後はポイと捨てられる。

「思いがけず冷たい夏の日曜だけが明白である」
カキ氷を食いながら私は言った。
そして幾分か私は凍え死んでいたのだった。

115

For example, you get a phone call from a woman who is not one who gets that

excited and the first thing after she opens her mouth she practically yells

"I've finally trained my lizards" and being told so

for a moment you *don't know what* she's talking about.

And then you realize that she's trained her lizards and you begin to want to see

the results of her training I think.

For example if you were to enter her house there would be 2 lizards.

The one with the white belly would be called Aantsu, the one with the purple

belly would

be called Moya.

Straight away she pokes Aantsu's head

taking this as a sign Aantsu rolls on his back

She also pokes Moya on the head, and Moya too rolls over on her back

then as her voice cries "change!"

Aantsu's belly turns purple and

Moya's belly turns white and

for a moment you *don't know what's* happening.

And then I think you'll notice how wonderful it is

and will want to see it again.

例えば普段あまりエキサイトする方ではない女性から

電話がかかってきて　開口一番まるで叫ぶかのように

「ついにトカゲを躾けたのよ」と言われると

一瞬なんのコトだかワカラナクなるだろう。

それからトカゲを躾けたことに気付き

彼女の訓練の成果を見たくなると　おもう。

例えば彼女の家に入って　トカゲが2匹いる。

腹の白い方をアーンツ、腹がムラサキ色の方をモヤ。

彼女はさっそくアーンツの頭をつつき

それを合図にアーンツは仰向けに寝転ぶ。

彼女はモヤの頭もつつく、モヤも仰向けに寝転ぶ。

そして「チェンジ！」という彼女の声で

アーンツの腹の色がムラサキになってて

モヤの腹の色が白くなったとすると

一瞬なんのことだかワカラナクなるだろう。

それから　その素晴らしさに気付き

もう一度見たくなると思う。

秘密のキミドリの

秘密のラッパや笛の音

秘密の辺に響き渡る

秘密の人が立ち上がる

秘密の人が取りもどす

秘密の目や鼻や口が

秘密の手を広げて

秘密にはみだして

秘密に騒がしい

秘密の花の割れた欠けら

秘密に鋭く

秘密に眠っている

秘密の騒がしさ

秘密の花の目を覚ます

秘密の花を取りもどす

秘密のキミドリの

秘密のラッパや笛の音

秘密にはみだして

秘密に騒がしさ

A Secret Yellow-Green

The secret yellow-green

secret trumpet or flute

echoes out toward a secret place

secret people stand up

secret people take back

secret eyes and noses and mouths

unfurl secret hands

secretly boisterous

secretly standing out

the broken scrap of a secret flower

secretly sharp

sleeping secretly

secret boisterousness

waking a secret flower

the secret yellow-green

secret trumpet or flute

secretly standing out

secretly boisterous

Gradient

Always at two o'clock in the morning, I heard the crying of all kinds of cats as though they had made the wrong plans. And for some reason there were many that were urgent. Completely up against a wall voices filled with immediacy. I liked cats with voices like that. Crying until they've used themselves up. I've always wanted to cry out like that but the prying eyes of my neighbors worry me and I never have. It's not that I didn't consider wrapping myself up in a thick futon and crying but I never have tried. I simply couldn't bring myself to cry. The cats' crying was somewhat exaggerated today nothing special. So I put in some earplugs and read my book. Anyway the cats that cried so much they used themselves up, of course, died on account of having used themselves up. At that moment I'm told that they cough up a hairball. It is boastingly written in books that these last hairballs give off the smell of flowers. Speaking of which around here there is always the smell of flowers. There is the absolutely unbelievably wonderful smell of flowers. It is not written in books and nobody knows which scent of which flower it is. The whole town is leaning. On such a comfortable slope I've often seen the rolling of hairballs.

勾配

　午前二時にいつでも、図り間違えたように様々な猫の鳴き声が聞こえた。何やら緊迫した声が多かった。真に迫っていてためらわない声があった。その声の猫が好きだった。自分を使い果たすまで鳴いている。私もそんなふうに鳴きたいのだが近所の目が気になって鳴いたことはない。布団に包まって鳴いてみようかと考えないでもなかったけれど鳴いてみたことはなかった。ようするに鳴く気にならなかった。今日の猫の鳴き声はどこか大げさなのでどうでもよかった。だから耳栓をして本を読んだ。自分を使い果たすまで鳴いた猫は当然、自分を使い果たしたという理由で死んでしまうのだが。その際に毛玉を吐くのだそうな。最後の毛玉は花の匂いがするのだと本には誇らしげに書いてある。そういえばこの近辺は欠かさず花の匂いがある。あまりに身も世もなく良い匂いだった。何の花の匂いなのかは本に書かれていないし誰も知らない。街全部が傾いている。気の置けない傾斜に毛玉の転がっているのをよく見かけた。

モティベイション

息苦しいまでに何の役に立たなくて

ほとんど耐えがたく私の心臓はくらくらとする。

やりきれないなと思いつつ

5時1分に宅を出るのである。

雨が横なぐりになっていた。

全てに備えていたつもりが傘を忘れている。

もう長いこと雨に濡れていないなと思ったので

とっとと意気さかんに　どぎついずぶ濡れである。

実に実に気の済むまで　どぎついずぶ濡れである。

火炎瓶

火炎瓶のようなオートバイに乗っていて壁に激突したのだ／衝突するのは目に見えていた／天気が良い日にかぎって壁に激突する／どちらかといえば和やかな雰囲気で激突する／「ベシャーン」と気楽な衝突だった／うんざりするほど激痛があった／街は大きすぎて／他に誰もいない／街はだれもいないほうが洗練されていた／街はめったなことでは驚かなかった／こぼれ落ちるみたいに気が遠くなる／だれかに電話をかけて／知っていることから話したいと思う／「朽ちかけた平日である」／「あからさまに頭が砕けている」／「鼻血ピューである」／「死なんてクソッタレだから」／「なるべく近づかないほうがいい」／「じゃあーねー」

MOTIVATION

Useless to the point of suffocation

mostly unable to endure my heart fluttered.

While thinking I can't manage it

I leave my house at 5:01.

The rain is pelting sideways.

I had intended to prepare everything but I am forgetting my umbrella.

Because it occurred to me that I haven't been wet from rain in a long time

revved-up and psyched I am utterly dripping wet.

Truly as if truly satisfied I am utterly dripping wet.

Molotov Cocktail

Riding a Molotov cocktail-like motorcycle I crashed head-on into a wall/I could see that I was going to crash/I only crash into walls on days with good weather/If you ask how it was, I crashed with an aura of calm/"Krak!" the impact was easy/There was enough pain to thoroughly frustrate/The town was too big/Nobody else was there/The town is more refined with nobody there/The town was not surprised by these reckless happenings/As if it were spilling away from me I began to lose consciousness/Call somebody/I want to start from what I know/"It is a weekday that had started to rot"/ "my head is clearly split open"/"Blood is spurting from my nose"/ "Because death is nothing but a *son of a bitch*"/"Whatever you do you should not get close"/"See ya."

忍耐強く赤い秒針が勤勉に回る。生まれ出る子どもは　待ちうける僕の手の中に落ちる。ただ巨大な
子どもだ。やむを得ず　僕は脱臼したんだ。右肩だった。
脱臼するのはいつも右の方なんだ。
母親の心臓はとっくに止まっている。
緩慢な沈黙のなか　せいぜい一秒か二秒　僕たちは潮風に吹かれているような気になっていた。

"安っぽい感慨だ" と決めつけて僕は沈黙に身を浸すのだった。

海なんてものは　もう全部干からび無くなってしまっていた。

ただ巨大な子どもが ただ巨大な鳴き声でもって　沈黙などはすぐに叩っき壊した。

ただ巨大な子どもをあやすように　母親がヴァギナで歯ぎしりめいた音を立てているだけ。

なれ合い

皮切りはタクシーの運転手でした。私がタクシーに乗り込もうと
したとき運転手は「私は人を殺したことのある運転手なのですけ
ど、よろしいでしょうか？」と言うので「どうでもいいですよ、
平野駅の辺りまでお願いします」と私の声は薄情だった。私の声
の方がよほど人殺しの似合う平らな声のように思えた。運転手の
声には思いがけず情感があった。事情はよく分からないけど無
防備な酢飯みたいな声をしていた。私は口当たりの良い人殺しと
価値のない話をした。猫にも想像妊娠があるという話をした。鼠
にも想像妊娠があるという話をした。ハエには想像妊娠があるの
か？という話をした。蚊には想像妊娠があるのか？という話をし
た。どちらからともなく回転しない寿司でも食おうということに
なって。私は口当たりの良い人殺しと鉄火巻きを食って。熱い茶
を飲んでいる。

Patiently the red second hand diligently moves around the clock. The
children being born fall into my waiting hands. They are utterly giant
children.
Inevitably my bones dislocated. It was my right shoulder.
It's always my right shoulder that dislocates.
Their mother's heart stopped beating completely.
Within that languorous silence at most for one or two seconds I felt
as though there was an ocean breeze blowing through us.

"What a cheap idea," I decided and had sunk my body into the silence.

The very *sea* is bone dry and had completely disappeared.

The utterly giant children with utterly giant voices the silence and the like
they soon bludgeoned and broke.

To lull the utterly giant children their mother is simply making the sound
of gnashing teeth with her vagina.

Cozy

The start of it all was the taxi driver. When I went to get inside the taxi, "I'm a driver who has killed people are you ok with that?" and as the driver tells me such, "it's nothing to me, please take me to the area around Hirano station" and my voice was emotionless. As my voice was quite flat I thought it was a voice more suited to be that of a killer. In the taxi driver's voice there was an emotion one would not think to expect. I don't know his circumstances but it was a voice that was as defenseless as rice and vinegar. I had a conversation devoid of value with a smooth-talking murderer. We had a conversation about how cats too can have phantom pregnancies. We had a conversation about how mice too can have phantom pregnancies. We had a conversation about, can flies too have phantom pregnancies? We had a conversation about, can mosquitoes too have phantom pregnancies? And then at some point in the conversation it came to pass that we decided that we should go and have sushi that doesn't revolve around in circles. I ate *tekkamaki* with a smooth-talking murder. I'm drinking hot tea with him.

In June when it's so hot they do not think of laundering blankets

even in their dreams the women

at dawn so very early carry boisterous instruments, taiko and the like,

walking around the thoroughfares singing songs in fits and starts.

The women wet their middle fingers with glistening spittle

thrust them into a swallow's nest made of mud

in that posture their bodies shudder.

Scars Are Scars

In memory the scars of boys unravel.

Their survival rate is 0 percent. The sun is a leaden hue.

Oxygen tanks and erectile tissue become friends, and public works projects and prostitution referral services have been married.

I have no expectations at all. A feeling of collapse spreading infinitely outward resembled self-absorption. Such varieties of emotion are stories from long ago that were flushed down the toilet.

Capital cities as well as the atmosphere were figments of the imagination, therefore both boys and girls got hard-ons.

"This thing called despair, besides I rather like it," spoke the scar of the boy of memory as though betraying a secret.

Because they were taking strong pain killers the scars too had quieted down.

600マイル離れたアパート

6月に毛布を洗おうとは夢にも思わないオンナ達は
明け方ずっと早くに太鼓やその他の騒々しい楽器を持って
通りを歩き回り　切れ切れに歌を歌う。
オンナ達は中指を光る唾液で濡らし
泥でできたツバメの巣に刺し
そのままの姿勢で身震いした。

傷跡は傷跡

記憶の中で男の子の傷跡は取り乱す。

生存率は0パーセント。太陽は鉛色。

酸素ボンベと海綿体が友だちになって、公共事業と

売春斡旋業者は結婚していた。

何にも期待はしていない。限りなく拡がっていく挫折感は自己陶酔に

似ていた。その種の感情はトイレに流された昔話なのだ。

首都も大気圏も絵空事だから、男の子も女の子も勃つのだった。

「失望ってのも、以外に好きだよ」と

記憶の中で男の子の傷跡は漏らすように言っていた。

効き目の強い鎮静剤を飲んでいたから傷跡も大人しくなった。

A Primal Scene

Various colors
as if to enframe having their way all around
really
remember
think it over
think of nothing
string instrument landscapes
plucked by fingernails
undress me
destroyed or the opposite?
an absolute comedy
and even if it were a tragedy even then
it would be interesting in equal measure
the two carry a common color
thinking it well
drove a stake into a cake
this or that and such
he and whomsoever
at some point it's petrifaction
on and on
thus and so
this afternoon
azure weather

原風景

いろとりどり

ふちどって ヤリまくった

実際

記憶する

つきつめて

何も考えない

弦風景

爪弾き

脱がせて

こわされる　それか逆？

徹底的に喜劇

別に惨劇だったとしても

同等に面白い

ふたりは共通の色を

持ってる

よかれと思って

ケーキに杭を打ち込んだ

あれこれとか

誰彼も

いつか化石っすよ

かくかく

しかじか

こんにち

青い天気

Yesterday the Afternoon Disappeared

Yesterday the afternoon disappeared

and tomorrow the night disappears

I light a fire

and your mamá is watching the flames

if you were to open up the inside of the inside of the fire and have a look

you'd find a rectangular shard of glass

find the horizon reflected in that shard of glass

I raise up the horizon

I plant a bulb

since your mamá says

"next time I want a salad bar"

The very words your mamá puts into her mouth—are quite a work of art

The angles of your mamá's shoulder pads

are indeed a poem

Six Six Years

Six six years, my room was a resort

on the table everybody intertwined

somebody grew tomatoes

a tomato had fallen beside the sofa

a room the same as it has always been

there was almost nothing to be gained

of course there are also those who don't think so

somebody swung their body without so much as a productive reason

somebody is carrying Japanese tea

somebody absolutely could not sleep

somebody adopted laziness as a life cycle

it was always humid and warm

hot vapor had overwhelmed the entire room

somebody fell from the window and crashed

the tomato beside the sofa remained the same as it has always been

昨日昼間が無くなって

明日夜間が無くなって

僕は火を整えて

君のママは火を見てる

火の中の中を開けてみたらば

四角いガラスを見つけて

ガラスに映る平地を見つけて

僕はその平地を整えて

僕は苗を植える

それから君のママが

「今度はサラダバーが欲しいわね」

と言うわけ

君のママの口にする言葉ね。芸術だよ

君のママの肩パットの角度

それは詩だね

六六年、私の部屋はリゾートだった

テーブルの上に誰もがもつれあった

誰かはトマトを栽培した

ソファの側にトマトが落ちていた

いつもどおりの部屋

得るものは殆んど何もない

勿論そう考えない人もいる

誰かは生産的な理由もなく体を揺らした

誰かは日本茶を運んでいる

誰かはまったく眠らなかった

誰かは怠惰をライフサイクルとして採用した

いつも湿っていて暖かい

暑気が部屋中を捕らえていた

誰かは窓から落ちてつぶれた

ソファの側のトマトはそのままだった

Dice Males

And I've also fixed my missing teeth/Let's fool around/It's nothing/I've got it all/Contradictions or gaps look good on you/I want to breathe/I lose myself in repetition/Whether it's right or it's wrong becomes meaningless/If necessary shall I go so far as to shed tears? How about I swim?/Some kind of excess and some kind of reflection/Reflection ends when it's reached the point at which it can't help but end/I'm going to splice reflections together to make new clothes/ignorant clothes I think/And if you feel like it you can become even more ignorant/Let's fool around/It's nothing/I've got it all/ That's all it is

A Day I Didn't Want to Laugh

A wife with a profile slack beyond words is melting some butter in a
frying pan sautéing asparagus. The wife's boyfriend
slices meat
dashing on pepper, salt, with a malevolent glance
adds garlic *confit* and onion fondue, adds au *jus*.
Although the mutton is dead it was beautiful.
Perhaps more than when living it is much more refined.
The slab of meat resembled a flower petal. More than the wife's profile
beyond words it was the slab of meat that caught one's eye.

Dice 男性

欠けた歯も直したし／ジャレ合おう／何でもない／すべてある／君は矛盾か空白が似合う／息がしたい／繰り返すことに夢中になる／正しいか間違いかはどうでもよくなってしまう／必要なら涙まで流しましょうか？　泳いだらどう？　何らかの過剰と何らかの反射／反射は終わるしかないところまできた時点で終わる／反射をつぎ合わせて新しい服を作る／無知な服だと思う／その気になればもっと無知になれる／ジャレ合おう／　何でもない／すべてある／それだけのこと

笑いたくない日でした

何とも横顔の間延びした奥さんはフライパンにバターを温め、アスパラ

ガスに火を通しています。奥さんのボーイフレンドは

肉を切り分けて

塩、コショウを振り、よこしまな目つきで

ニンニクのコンフィとタマネギのフォンダンを添え、焼き汁を添える。

仔羊の肉は死んでいるのに奇麗でした。

きっと生きているときより　ずっと研ぎ澄まされています。

肉片は花びらとよく似ていました。何とも奥さんの横顔よりも人目を引

く肉片でした。

Morita

With a fit of coughing

the birth pangs began

there is a crisp ringing in my ears

"these birth pangs are really sharp"

I voiced as if singing

telephoned the midwife

At the window until the midwife arrived

I gazed outside

several objects that appeared to be celestial bodies were falling

there was also a merry-go-round

floating in the sky

at the very time when these things too

had finally grown tiresome to me

the midwife playing a flute

entered the room

she had cultivated a beard

this was such surrealism

that one could think it pitiful

モリタ

咳き込んだ拍子に
陣痛が始まって
颯爽とした耳鳴りがする
「この陣痛はえぐいなあ」
私は歌うように声に出して
助産婦に電話を掛けた
助産婦が来るまで窓辺で
外を眺めた
天体らしいものがいくつも落ちて
メリーゴーラウンドが空中を
漂っていることもあった
いよいよそれらも私にとって
つまらなくなった頃合に
助産婦は横笛を吹いて
部屋に入ってきた
彼女は口ひげを蓄え
哀れに思えるほどの
シュールレアリスム

The Things I Know

The paints mixing together on a troubleless summer day/to tell the truth evening rain

is also a mélange of colors/falling to the ground without hesitation/

greenery as well as minor wounds are filled with color/

everybody was crying/those drops even those too are a mélange of colors/

those voices too are filled with color/filling my cupped hands with color I wash my face/

putting the needle down on a record cut into rings/from the clockwise grooves

I could hear color furnishing a good view/I rendezvous with color/

typical roistering/

had taken a detour and was sleeping/I had a dream and did not look away/

even in the back of my mind I am cultivating color/zero-degree color that could even

freeze summer days/

On My Way

It was nearly daybreak.

I was walking and chewing gum.

A languid wind passes through my body.

A stark naked homeless man had fallen down on the side of the road

and it seemed that he

had fallen away from the sky.

On his chest there was an *irezumi* tattoo of an exquisite flower.

Ultimately it was beautiful

and two deceived butterflies

had come to suck

nectar from it.

分かっていること

混ぜ合わせる絵の具は　つつがなく夏の日に／じつをいえば夕立も

色の寄せ集めであり／ためらわず地面に落ちている／

木の茂みも短い傷口も色彩に満ちています／

誰彼が泣いていて／滴り　それさえも色の寄せ集めであり／

その声も色彩に満ちています／色彩をすくい上げて顔を洗い／

輪切りにされたレコウドに針を落とすと／右回りの溝からは

眺めのいい色彩が聴こえる／色彩と待ち合わせをして／

ありふれて騒いでいる／

遠回りして眠っていた／目を背けないで夢を見た／

脳裏にも色彩を飼っています／夏の日も凍結させる零度の色彩を／

行き掛かり

明け方だった。

僕はガムを噛んで歩いていた。

緩慢な風が僕の体を通り抜ける。

全裸のホームレスが道端に落ちていて

そいつは空中から

はがれ落ちて来たみたいだった。

胸元には緻密な花の入れ墨があって。

あげくの果て綺麗で

騙された二羽の蝶々が

蜜を吸いに寄り付いていた。

IN Nihon

IN Nihon. A garden decorated in electro. Two just barely sensual

peacocks. In our house grandfather lit grandmother's cigar

and passed it to her. Women smoke/men light.

As for the elderly, they have an obligation to gaze. My grandfather

and grandmother are gazing outside through a large window.

In their field of view peacocks are engulfed and borne off in a

tornado. Black rabbits scamper at their feet.

"Such a Platonic stark view," said my grandmother softly.

My grandfather did not think so.

IN日本

IN日本。エレクトロで色どられた庭。きわどく官能的な
庭の孔雀ら。宅内では祖父が祖母の葉巻に火を
つけて渡した。女性は吸う／男性は火をつける。
老人には眺めるという義務がある。わたしの祖父祖母
が大きな窓の外を眺めている。視界には竜巻に巻き
上げられる孔雀ら。足元に黒い兎がはしりまわってる。
「プラトニックな殺風景やね」と祖母は小声で言った。
祖父はそう思わなかった。

Rolled over. Insane. Us. Making records by compressing the bones
of a fisherman who could not keep still. The fishing vessel sailing
through the center of town at a speed of more than 2 hundred km was
seen too much from the veranda.

"The reason you are rescuing my emotions is because you killed
my emotions," sang the record made with the bones of the fisherman.
But I have no idea to whom the record is singing. We applauded in
the dark. Without any "do this" or "do that" being said. We were
sending out vigorous applause.

Moving along. There are no moves left. Gone insane~. In what way
had we. I don't even want to say if we are trapped or not. Anyway.
Clearly. On New Year's Day nineteen eighty nine. Because the boy
was so stylishly wearing a maternity dress while riding a BMX and
jumping from the thatched roof of our house he was completely
covered in injuries. The scars of that boy remain in his brain. Rift-
like injuries. Thrust. Weightlessness. These are the things we know
about that boy.

"Can meet when we can can't meet when we can't. The best times
are the best the worst times are the worst. It's always that way.
Amateurs fuck off," the boy spat out while touching his injuries.
From New Year's Day nineteen eighty nine. I don't even catch a
glimpse of that boy.

However. I would not trade it for anything. The fishing vessel sailing
through the center of town at a speed of more than 2 hundred km
was seen too much from the veranda. If wishes come true. It would
be alright if it had been that boy piloting the aberrant fishing vessel.

くるた

ごろんと。狂夕。僕等は。居たたまれない漁夫のお骨を圧縮して
レコードを作ったり。街ン中を２百キロ以上もの速度で走ってる
漁船が ベランダから見えすぎていた。
"お前が俺の感情を救うのは　お前が俺の感情をブチ殺したのが動
機だよ" と漁夫のお骨でできたレコードが鳴っている。誰に向け
て鳴ってるのかは分からないが。暗闇で僕等は拍手した。ああし
ろこうしろと言われることなく。盛んに拍手を送っていた。

　引き続き。抜き差しならず。狂テラ〜。どんなふうに僕等が。
抜き差しならんのかは教えたくもない。とに角。確か。一九八九
年の元日に。マタニティードレスを着こなした男の子はBMXに乗
ったまま　僕等の家の瓦屋根から飛び降りたりしてたから　怪我
ばかりだった。あの男の子の傷跡が脳内に残ってる。断層的な傷
跡。推進力。身軽さ。あの男の子について僕等が知っていること。
"会える時は会えるし　会えないときは会えない。最高の時は最
高だし　最悪のときは最悪。いつもそんな感じ。シロートは　す
っこんでてよ" と男の子は自分の傷跡に触れながら言い放った。
一九八九年の元日から。あの男の子を見かけもしない。
しかし。何ものにも代え難く。街ン中を２百キロ以上もの速度で
走ってる漁船が　ベランダから見えすぎていた。願いが通るなら。
気違い沙汰の漁船を操縦してるのが　あの男の子だったらいい。

Passing By

Did the condoms pretentiously wither away and die?

Would it appear even as though they had grown pessimistic and fallen asleep?

I don't really care which one it is.

At most it is merely a few condoms lying on the road.

Even so was an old woman bent at the waist distressing over it?

"These abandoned condoms are to blame. Basically that is what it is."

Mustering both inspiration and intellect did the old woman say these things

accordingly?

Then did she snatch an indeterminable quantity of tempura oil from a house

somewhere and conspire to commit mutual self-immolation with the silent

condoms?

By setting fire to tempura oil does virtue itself disassemble and burn nicely in

a golden color?

So as not to let the fire go out should we make fervent stares and add

firewood?

通りこしている

これみよがしにコンドームが衰弱して死んだのかい？

悲壮感を募らせて眠ってるようにも見受けられるのかい？

本当はどちらでも構わないのに。

たかがコンドームがタプンとして路上に横たわっているだけなのだ。

それなのに腰の曲がった老夫婦が心を痛めていたのかい？

「放置された　このコンドームのせいだよ。つまり　そういうことなのだよ」

知性と霊感とを駆使して老夫婦は声を揃えて言うのかい？

それから把握出来ない量の天ぷら油を何処かのお宅からカッパラって来て

無言のコンドームもろとも焼身心中を図ったのかい？

天ぷら油に火を点けたら道徳なるものが解体されて黄金色によく燃えるのかい？

火を絶やさぬよう僕たちは熱心な眼差しをして薪をくべるのかい？

いつもの普通の蛇口に目をうばわれる。そういうの　いいよ。
しばらくするとそれにも慣れてしまうけど。オレンジジュー
スっぽく見えるスピーカーから。まだ鳴きなれないセミの声
が聞こえた

Normal Everyday Faucets

My eyes are drawn to normal everyday faucets. Those

are good. But after a while I become inured even to

those. From stereo speakers that look like orange juice.

I heard the hesitant song of cicadas

The Rain Continues to Fall Indiscriminately

"The rain continues to fall indiscriminately"

"The lips of a newly familiar woman glisten glaringly"

"The woman is embracing a man with a crumpled ear"

"They are embracing throughout the room"

"They were a tropical rain forest as if dripping with moisture"

"The procession of the shrine festival could be heard at a distance"

"A butterfly colored a red so harsh it was unlucky fluttered in through the window"

"Go ahead, flitter about as you please"

"The entire space was light-heartedly submerged"

"The newly familiar woman with glistening lips is submerged"

"The man with crumpled ears is submerged"

"The procession of the shrine festival is submerged"

"The lips of the newly familiar woman"

"Were killed by an eel emitting electrical charges"

"The crumpled ear"

"Was killed by an eel emitting electrical charges"

「雨が見境なく降り続いています」

「先の知れた女の唇がぎらぎらと光っています」

「女は耳のねじれた男と抱き合っています」

「部屋の至るところで抱き合っています」

「したたるような熱帯雨林でありました」

「遠くに祭りばやしが聞こえます」

「不吉な程どぎつい赤色の蝶が窓から入ってくる」

「どうぞ気兼ねなく飛び回ってください」

「そこらじゅうが気軽に水没しています」

「先の知れた女の唇が水没しています」

「ねじれた耳が水没しています」

「遠くの祭りばやしが水没しています」

「先の知れた女の唇が」

「放電しているうなぎに殺されてしまいました」

「ねじれた耳が」

「放電しているうなぎに殺されてしまいました」

As for myself I have a *tanka* friend.

Among us *tanka* friends

there is a person with a criminal record.

Sparrows are perching

on the shoulder of the person with a criminal record.

one sparrow

two sparrows

three sparrows

four sparrows

I don't know if that is a large number

or not.

The Last Flower I Will Ever See in This Life

On the other side of the ice

there was a garden in which

in an unspoken manner a table with a floral print

was scattered in a casual way.

With the configuration that

just as he was on the verge of attempting to become a good father he

would be killed by his favorite horse

he

gave forth a short chaotic laugh

fell

face down.

On top of that

the helicopter

his aunt pilots

crashed due to

mechanical failure.

和んだ空気

私には短歌仲間がいます。

私達短歌仲間には

前科を持った人が一人います。

前科を持った人の肩に

すゞめがとまっています。

一羽

二羽

三羽

四羽

その数が多いのか少ないのかは

わからない。

この世で目にする最後の花

氷の向こうがわに
クチナシの花模様のテーブルが
何気ない感じで散在している
庭がありました。
よい父になろうとしていた矢先に
愛馬に蹴り殺されるという設定で
彼は
短く混乱した笑い声をあげ
うつ伏せて
倒れました。
その上に
伯母の操縦する
ヘリコプターは
機械の故障で
堕ちたのです。

Slam a tyrannical sound into

your own tape deck. All of it. That means noise. Self-proclaimed paranoia.

It is I who am the fried oyster that terminates. If not then

suffering clear plastic. Perhaps with extenuating circumstances.

Daily my pointer finger was absolutely black.

My insistent second cousin's suicide bombing took too much

of a Milky Wayish hallucinogen and

regrettably cut off its own head. With a machete? With an axe?

With an electric saw? As not one shred of evidence has been left behind it was

STRANGE. VERY STRANGE.

Yet it was just a Sunday vetted as much as it could have been.

The thoroughly dissolved sun was flickering excessively.

I want to go to Tahiti/I want to go to Tahiti/I want to go to Tahiti/I want to go to Tahiti/I want to go to Tahiti/I want to go to Tahiti/I want to go to Tahiti/I want to go to Tahiti/Nogami is shouting that he wants to go to Tahiti/Since he always shouts in a refined voice/a boy is crying/a girl is crying/indiscriminately/the late morning's laundry is wavering/the boy becomes an adult and is crying like a child/the girl becomes an adult and is shopping/buys up record albums, Takara *shōchū*, a locomotive, rice paddies, a building with walls or floors paneled in glass where goldfish and *shishamo* are swimming, Siamese cats, a bidet, ethnic music, an album by Tamori, a black pyramid, thick pale blue lasers/scatter rays of light into midair on a public holiday/drums echo endlessly/ indigenous/Nogami stands and urinates while playing the guitar psychedelically/several hundred party people are rolling around/ mountains are erupting/what time is it/everybody, was engulfed by lava/"Do you want to go to Tahiti?"/she is whispering in Nogami's ear/now that I think about it it wasn't that I didn't, Nogami muttered in the woman's ear.

タヒチに行きたい／タヒチに行きたい／タヒチに行きたい／タヒ
チに行きたい／タヒチに行きたい／タヒチに行きたい／タヒチに
行きたい／タヒチに行きたい／タヒチに行きたいと野上さんがわ
めいている／上等な声でわめくものだから／男の子が泣いて／女
の子が泣いている／無闇矢鱈／昼前の洗濯物が揺らめいて／男の
子は大人になって子供のように泣いている／女の子は大人になっ
て買い物をしている／円盤、宝焼酎、機関車、水田、壁や床がガ
ラス張りで金魚と ししゃもが泳いでいるビルディング、シャム
猫、ウォシュレット、民族音楽、タモリのアルバム、黒いピラミ
ッド、青白くて太いレーザー、を買い占めて／祭日の上空に光線
を飛び交わせる／延々ドラムが反響している／土着／野上さんが
サイケデリックにギターを弾きながら立ち小便をしている／何百
人のパーティー・ピープルが転げ回っていて／山々が噴火してい
ます／何時か、皆、溶岩に飲み込まれました／「タヒチに行きた
い？」と／女が野上さんの耳元に囁いている／よく考えたら そう
でもなかった、と野上さんは女の耳元に呟いていた。

生気、管理、不要物

自前のカセットデッキに横暴なサウンドを

つぎ込んで。全部。だからノイズ。自称パラノイア。

我こそは終結するカキフライ。でなければ

苦悩する透明ビニール。多分情状酌量。

日替わりに人差し指が真っ黒だった。

イケイケのマタイトコの自爆犯は銀河的幻覚剤の飲み過ぎで

自分の首を切り落としてしまった。ナタで？斧で？

電動ノコギリで？証拠たるものは何一つ残されていないから

FUSHIGI。MAKAFUSHIGI。

でもそれなりに淘汰されただけの日曜日。

とても溶解してしまった太陽が矢鱈チカチカしていた。

A Red Former Hotel

In your neighborhood a former hotel once stood. The day after
tomorrow, the former hotel with the name Strawberry will be
completely blasted away during lunch hour.
It will be blasted away by time.
Plenty of onlookers should be there. Because everyone
loves dynamite and that moment of destruction and such.
You won't be allowed to view it up close but the
billows of dust, the smell of burning and such will reach
everyone reasonably well. Perhaps even the pleasant
scent of strawberries too will be subtly mixed in.
It's not certain. It's just that I have the feeling that's how it will be.

Giant

listening to giant music

looking at giant chrome

reading a giant book

primping before a giant mirror

go out to meet a giant lover

in a giant automobile

seeking giant Vietnamese cuisine

eating giant spring rolls

at a giant hotel

bringing in a giant amp

playing a giant guitar

a giant lover

beats a giant drum

in the aftermath of a giant release

has a giant tranquility

and has sunk into a giant slumber

赤い元ホテル

御近所に元ホテルが建っていました。苺という
ナマエのついた元ホテルは明後日、ランチの
時間に吹っ飛ばされるんですよ。
たくさんの見物人が来てくれるはずだよ。みんなダイナマ
イトとか破壊のひとときが好きですからね。
ほんの近くで見るという訳にはいかないけど それなりの
砂煙とかこげた匂いはみんなに届きますよ。苺のいい香り
も微かに混じっているかもしれません。
定かではないよ。そういう気がするっていうだけ。

でかい

でかい音楽を聴いて
でかい発色を見て
でかい本を読んで
でかい鏡で身だしなみを整えて
でかい恋人に会いに行く
でかい車で
でかいベトナム料理を探して
でかい春巻きを食べて
でかいホテルに
でかいアンプを持ち込んで
でかいギターを弾いて
でかい恋人は
でかいドラムを叩いて
でかい発散の後
でかい静けさがあって
でかい眠りにひたってる

An Average Daily Life

I can't bear pretending as if I hadn't seen anything with everything unchanging. Survival is an action of the same order as urination. In a small room equipped with a sunken hearth, a deficient sensibility will dull or sharpen. The television was so savage that it was almost frivolous. A woman with shoulder pads in her jacket is killing time by ripping them out and casting them away. I wanted to smash up the television with the karate I had learned at some point. But smashing up a television with karate is not an easy task. I heaved the half-destroyed television out of the window and drank oolong tea. In the small room equipped with a sunken hearth it was extremely silent as though it were tickling my sides. It was an enigmatic kind of mellow. Just as I slipped into a lazy mood a man who slurs his words broke into the small room equipped with a sunken hearth. He had a face that looked as if he would mire himself in corruption any number of times. I told him, "You have a face that looks as if you would mire yourself in corruption any number of times." "The opposite may also be true," said the man in slurred words. The man was so impractical that it would be fair to say he was brutish. If I were to liken him to poison I would think him a fatal dose. He was such a meticulously toxic intruder as to be overwhelmingly common. I wanted to smash up the intruder with the karate I had learned at some point. But smashing up an intruder with karate is not an easy task. I heaved the half-destroyed intruder out of the window and drank oolong tea.

平均な日常生活

見てみぬ振りして何ものも不変でいられない。生存することは放尿と同列の行為だな。掘りごたつの備えられた小部屋で乏しい感受性は鈍磨するどころか鋭敏になる。軽薄なくらいテレヴィジョンがサツバツとしていた。肩パット入りのジャケットを着ていた女の人が肩パットをそぎ落として暇を潰している。いつか習った空手で私はテレヴィジョンを粉砕にしたかった。それでも空手でテレヴィジョンを粉砕するのは容易いことではない。半壊になったテレヴィジョンを窓から放り投げて烏龍茶を飲んだ。脇腹をくすぐられてるみたいに掘りごたつの備えられた小部屋は極めて静か。やや得体の知れないメロウだったよ。気が弛んでたところにロレツの回らぬ口の男が掘りごたつの備えられた小部屋に闖入して来る。男は何回でも汚職しそうな顔だった。「何回でも汚職しそうな顔だね」と私は男に言った。「逆もまた真なり」と男はロレツの回らぬ口で言った。「その逆もまた真なり」と男はロレツの回らぬ口で言った。男は実用的でなかった。ワイ雑と言って差し支えなく男は実用的でなかった。この男を毒薬に例えるなら致死量に思える。掃いて捨てるほど念入りに有害な闖入者だった。いつか習った空手で私は闖入者を粉砕にしたかった。それでも空手で闖入者を粉砕にするのは容易いことではない。半壊になった闖入者を窓から放り投げて私は烏龍茶を飲んだ。

Broken Hands

Huh oh, well my public phone has broken.

My public phone was so broken I could laugh.

Huh oh, well destitution is fun.

I to the extent that I could

accepted that my public phone was simply broken.

On top of the public phone my *Ise ebi* lobster was broken.

Even though I hadn't asked anybody to do it,

spurting out all sorts of vibrant multicolored this and that my

Ise ebi lobster was broken.

Off

Building a log cabin on my own

the greater part of my emotions are aroused.

Since I have prepared a guillotine

half out of whimsy I chopped a daikon.

That daikon chopped clear through the middle

for all time, and then for all time was vivid.

In any case after my gaze had been transfixed for awhile

I exhale sharply.

Becoming sharp, becoming too sharp

my breath was somehow a sword fight.

こわれた手

なんか　ああ、もう　わたしの公衆電話がこわれた。
わらってしまうほど　わたしの公衆電話がこわれていた。
なんか　ああ、もう　欠乏が楽しい。
わたしは　わたしなりに
わたしの公衆電話がこわれたことを　ただ　受け入れていた。
こわれた公衆電話の上に　伊勢海老がこわれていた。
誰にも頼まれていないのに、
あざやかないろいろを放射しながら　伊勢海老がこわれていた。

オフ

自力で丸太小屋を建て

感情の大半は発情してる。

ギロチンも用意していたから

オモシロ半分に大根を切ってみた。

中央部で　すぱんと切れた大根は

いつまでも、それからいつまでも生なましかった。

いずれにしても　ひとしきり目を奪われた後

私は鋭角に息を吐く。

鋭角になって、鋭角になりすぎて

私の息は　なんとなく刃傷沙汰だった。

III.

I put a small sniper in my bag

and head out. If I remember to. The sniper from

a gap in the slightly opened zipper. Haphazardly or perhaps

sincerely I said, "Good morning."

Because he says, "So, is there anybody here who

wants to eat watermelon?"

Since I had already taken my breakfast

I said, "No thanks" and declined. A short while later

from the gap in the zipper. Anything and everything

at this strange pace. Watermelon seeds are fly

ing. When the watermelon seeds fall to the ground

they make the sound "plink" and break. And this

was slowly and deeply. It was a perfect scale.

On Emeralds

I'm a single mother/because "delight"

lay on the other side of "sanity" and "ins

anity" I go out on

a walk/compared to two days ago it's warmer outside/

greetings with the neighbors too are hurried/

matching the time of a waltz/I whirl/close

my eyes/think of all kinds of living things

/

a snowy owl/I want to see it in person

/

a Malaysian sun bear/I want to see it in person

/

with this thought as an opportunity/I stop whirling

/

and there greet my neighbors anew

引 き 算 と 黒 色

鞄に小さな狙撃手を入れて

外出する。気が付けば。

狙撃手は少し開いたジッパーの

隙間から。出鱈目にあるいは

切実に「おはよう」と言った。

「で、すいかを食べたい人は

いるかしら？」と言うので。

私は朝食をいただきましたから

結構ですと断った。しばらくすると

ジッパーの隙間から。何もかもがこう

変な速度で。すいかの種が飛んで

いる。すいかの種は地面に落ちると

パリンと音を立てて割れた。それは

ゆっくりと深く。完璧な音階でした

エメラルドについて

わたくしはシングルマザー／「正気」と「狂気」のむこうに「歓喜」があったので散歩へ出る／二日前と比べて外は暖かくなっていた／隣人との挨拶（あいさつ）もそこそこに／ワルツの拍子に合わせ／回転する／目を閉じる／もろもろの生き物のことをおもう
／
シロフクロウ／生で見たい
／
マレーグマ／生で見たい
／
この考えをきっかけに／回転とまる
／
そこで改めて隣人にあいさつ

211

Everyone

It is quite a morning

An unyielding morning

Reverberating

Kur-thungk kur-thongk

the sun is rising

until it's satisfied

In other words

it's a glorious morning

Of all days

a glorious morning

We suffocated

what you might call

the end of spring

Everyone

it is quite a morning

This unyielding morning

resembles a flower of some sort

It resembles a flower

which sets my heart racing

as much as this

I have a friend called Nada/he will always be tall and only his hair had a sharp appearance/"My bangs are New Wave," mumbled Nada/I don't know the circumstances but it was as if he was saying it to himself and seeming a bit stupid/beyond his stupidity/ Nada was a kind of fantasy/Nada picked up an object/a faulty amp, a faulty turntable, a faulty television, a faulty printer, a faulty wall clock, a faulty synthesizer, a faulty electric guitar, a faulty tape recorder, a faulty mic, a faulty stove, etc/plugging the mic into the amp Nada is singing/outrageously in a high-pitched voice/he was singing, "if I could play the piano〜"/his singing voice/was glib to the point where it was coughed out and thrown away and so it was fun/the faulty amp is burning/the faulty turntable is burning/the faulty television is burning/the faulty printer is burning/the faulty wall clock is burning/the faulty synthesizer is burning/the faulty electric guitar is burning/the faulty tape recorder is burning/the faulty mic is burning/the faulty stove is burning/etc is burning/

皆さん

皆さん
まったくの朝です
ゆるがない朝です
カトンコトンという
音を響かせて
気が済むまで
陽が上がっています
つまりは
素晴しい朝です
よりによって
素晴しい朝です
いわゆる晩春の
息の根を
私達は止めました
皆さん
まったくの朝です
ゆるがない朝は
何かの花に似ています
これほど
どきどきとさせられる
何かの花に似ています

変愛小説

名田という友人がいる／いつまでも背が高くて前髪だけ鋭利な感じがあった／"僕の前髪はニューノーウェーブ"と名田は呟いた／事情は分からないけど自分に言い聞かせているみたいで間が抜けている／間抜けを通り越して／名田はある種のファンタジーだった／名田は物を拾った／不健全なアンプ、不健全なターンテーブル、不健全なテレビ、不健全なプリンター、不健全な柱時計、不健全なシンセサイザー、不健全なエレキギター、不健全なテープレコーダー、不健全なマイク、不健全なストーブ、etc、／アンプにマイクを繋いで名田は歌っている／はなはだしく高い声で／"もしもピアノが弾けたなら～"と歌っていた／歌声は／吐いて捨てるほどぺらぺらしてて楽しい／不健全なアンプが燃えている／不健全なターンテーブルが燃えている／不健全なテレビが燃えている／不健全なプリンターが燃えている／不健全な柱時計が燃えている／不健全なシイセサイザーが燃えている／不健全なエレキギターが燃えている／不健全なテープレコーダーが燃えている／不健全なマイクが燃えている／不健全なストーブが燃えている／etcが燃えている／

Hi・児

Chieri Tuberculosis

and Stroke Sabio

these two were gambling all throughout Europe

winning money everywhere

hiding behind a waterfall

they are the children who had built a

multicolored pyramid.

The Resident

The sweat and breath of people

exhaled all over town, in the middle of the night

living on aimless talk

Dancing laughing

turntables will continue to be sold

Two trash men

and one trash woman were going at it every which way

Living or dying

I wake up in the morning. Then, I tell lies.

That is my job.

住人

夜中、街中に放出される

人々の汗や息

無駄口で生きている

踊ったり笑ったりして

ターンテーブルは売れ続ける

クズ男二人と

クズ女一人はヤリまくっていた

生きているか死んでる

朝起きる。で、嘘をつく

それがわたしの仕事

ハイ・ジ

結核のチエリと

脳溢血のサビオ

ふたりは

欧州中の賭場で

片端から稼ぎ

滝の裏側に隠れて

色とりどりの

ピラミッドを建てた児童

I am casting a fishing line that no one else would want into a fish pond. I have not the least inclination to catch a fish. A man with slight shoulders was also casting a line into the fish pond. Catching a fish was out of the question. By fishing side by side it was as though we had some kind of relationship and as though we had no relationship at all. To begin with from the start since we had no relationship for better or for worse we had rejected the idea of having a relationship. "Fishing is pretty savage," the man with slight shoulders said to himself.

"If I get tired of fishing I'm starting a motorcycle gang in Russia," said the man with slight shoulders as he continued to talk to himself. "Do whatever you like," I said to myself. Notwithstanding the fact that we had no intention of catching any fish, we caught a golden red snapper. The eyes of the red snapper were utterly void and without a second thought we were seized with dread.

What Are You Looking at?

Not that it really bothers me but

my Sunday is all wrong

an awful man came in

a woodpecker flew in

soon enough the sun was beating down

I open up my seafood restaurant

find

a sleazy talk show on AM RADIO

the awful man

keeps listening to it

the woodpecker is glaring at me

apart from those two

my customers aren't bad

誰も望まない釣り糸を釣堀に垂らしている。魚を釣る気は毛頭な
い。ひっそりとした肩幅の男も釣り糸を釣堀に垂らしていた。魚
を釣るなんて論外だった。私たちは隣り合って関わりあるようで関
わりがないのである。そもそも始まりから関わりがないのだから
良きにつけ悪しきにつけ関わりを持つことを拒絶していたのであ
る。「釣りって残忍だね」ひっそりとした肩幅の男は独り言を言っ
た。

「釣りに飽きたらロシアで暴走族を立ち上げるつもりなんだ」ひっ
そりとした肩幅の男は独り言を続けた。「勝手にやってろよ」私は
独り言を言った。魚を釣る気がないにも関わらず私たちは金色の
鯛を釣り上げた。よく考えるまでもなく鯛の目がどこまでも空虚
で私たちは恐ろしくなった。

何見てる

たいして気にならないんだけど

わたしの日曜はまちがっている

ヤなやつがきて

きつつきが飛んできて

そのうちに日が照りつけて

わたしはシーフードレストランを開く

AMラジオで自堕落なトークショーを

見つけて

ヤなやつは

そればっかり聞いてて

きつつきはわたしをにらんでる

こいつら以外の

客筋はわるくない

It was right after I had killed a cow.

Even the dead cow has contours.

The eyes of the dead cow have depth.

Dueling with cows was my side job.

My main job is singing tenor.

If they have no love

I want to say that all tenors are beasts.

Tenors who have lost their love are not few.

Tenors who have settled their love accounts are not few.

I am among those tenors who have settled their love accounts.

I want to say that my whole body without remainder is a beast.

I am tremendously ashamed of this.

If they have no love

I want to say that all tenors are trash.

Please Do Not Laugh

I have a wig that I have hardly ever worn. There is nothing to fasten it with.

A stiff wig. "It's damn stiff!" he

thinks. In the afternoon heat the wig gleams. It traces a circle. Pink

and silver gleam. "This is amazing!" he

thinks. Then he utters "crazy" once. "Crazy" means "is crazy." Or it means

"my beloved."

告ぐ

牛を殺したところだった。

死んだ牛にも輪郭（リンカク）がある。

死んだ牛の眼差しにも奥行きがある。

牛と殺し合うのは副業でした。

本業はテノール歌手なのです。

愛が無ければ

全てのテノール歌手は野獣だと言いたい。

愛を喪失（ソウシツ）したテノール歌手は少なくない。

愛を清算したテノール歌手は少なくない。

私は清算した側のテノール歌手なのです。

私の全身余すところなく野獣だと言いたい。

途轍（トテツ）もなく恥ずかしい限りです。

愛が無ければ

全てのテノール歌手は塵屑（ゴミクズ）だと言いたい。

ほとんど着たことがないかつらがある。なんの仕掛けもない。固
いかつら。固いぜ、と彼

は思う。昼の暑気のなか かつらが閃光する。円を描く。ピンクと
銀色の閃光。すごいぜ、と

彼は思う。それから声に出して「くるとる」と言ってみた。「くる
とる」とは「狂っている」という意味。あるいは「親愛な君」と
いう意味。

With a calm visage

my mid-level executive father-in-law

across most of his back

has had inked an *irezumi* tattoo of a pine tree

from that dazzling *irezumi*

with a calm visage

comes a scent of pine

Around the Yeti

I've sold my body for want of money

I am eating *yuba* tofu with the tension of murder

Out of the blue there was a phone call from the Yeti

The Yeti

was an old friend who could be called a regrettable connection

The Yeti brought some *shōchū*

and shortly thereafter came to my room

We spoke of old times while we drank

We probably laughed as we spoke of meaningless things

The more meaningless things are

they are complete enough to be substantial

平気な顔で

中間管理職の義父は

背中のほとんどに

松ノ木の入れ墨を施している

めくるめくその入れ墨からは

また平気な顔で

松の匂いがする

雪男の辺り

金ほしさに体を売ったことがあります

人殺しのテンションで湯葉を食べています

雪男から何の気なしに電話がありました

雪男とは

くされ縁というにふさわしい旧友でした

雪男は焼酎を持って

間もなく部屋にやって来ました

僕たちは飲みながら昔の話をしました

多分笑いながら下らない話をしました

下らなければ下らないほど

物々しいくらい充実しています

Do You Understand?

Always sleep deprived and unable to give my all

my mind completely fills with you, halfway up

a broad hill

pretending to be dead may also be a good idea. Thinking over such things

and picking up a handbag with

HAPPY MANUAL

embroidered on it.

Inside the handbag there was just one

serving of tofu, because it was so white it was hard to breathe

my white blood cells become lost halfway up

the very broad hill

and my red blood cells are ablaze. My blood. Thrilling.

Is this a good omen? Is this a dangerous omen?

Is there any hope? Is there not even one iota of so-called hope?

Living a long life also might not be such a bad thing. Thinking so

in a completely disheveled fashion

I also forget your name

and when I lightly press the center of the tofu so white it is hard to breathe

it sounds something like a toy piano.

I recalled that the world is just a flimsy thing.

And it became more and more humorous and everybody

only lives once.

At night, I grab another's hand. In the afternoon, I forget myself.

The world grows dark, grows

light. Moistens.

Because I require no time to cast off my reserve,

I cut across the middle of the very broad hill and head toward the sea.

Instead of being absorbed, I want to absorb. Thinking such things,

surrendering to action,

to love until I lose self-consciousness is my ideal.

わかる？

いつでも睡眠不足でガンバレない僕の
頭の中は君でいっぱいになって、長い
坂の途中で
死んだフリするのもいいかも。とか思ったり
HAPPY MANUAL と
刺繍されたハンドバッグを拾ったりしていた。

ハンドバッグの中には豆腐が一丁だけ入って
あって、胸苦しいくらい白いから
僕の白血球は実に長い坂の途中で迷子に
なってしまうし
モクモクと赤血球は燃えている。血が。騒ぐ。

良い兆候なのか？ 危ない兆候なのか？
希望はあるのか？ 希望なんて微塵もないのか？
長生きするのも悪くないかも。とか思ったり
完璧にダラしなく
君の名前も忘れてしまって、
胸苦しいくらいに白い豆腐の真ん中を軽く
押してみたらトイ・ピアノに似た音が鳴った。

世界はマヌケだっていうことを思い出した。

ますます滑稽になって誰もが

一度だけ生きる。

夜、手を握る。昼間、自分を忘れる。

世界は暗くなってみたり、明るくなってみたり

する。濡れたりしている。

打ち解けるのに時間はいらないから

僕は実に長い坂の途中を経由して海へ向かう。

のめり込むより、めり込みたい。とか思ったり。

行為にゆだねて、

自意識が無くなるまで愛し合うのが理想。

IV.

One Dark Night in Late Spring

One dark night in late spring
I took a lantern and fractured the darkness with it

In the gaps of the fractured darkness
I could only see the ground

The ground was clear and felt like jelly

Inside a few fish are swimming

The fish had fins but
it seemed as though they didn't know
how to use them

I feel fatally shallow

The ground has a
seemingly unfathomable depth

ある晩春の闇夜

私は提灯を持って闇を壊しました

壊れた闇の隙間に
地面だけ見える

地面は透明でゼリーの触感

そのなかをいくつかの魚が泳いでいる

魚にひれはありました　然し
それをどう扱うのかは分かっていない
ようだった

致命的に浅はかな気がします

地面は奥の知れないような
深さを持っています

Goodbye Scissors'. . .

Due to the inertia of careful preparedness an ordinary Saturday

for some reason a day when I had been remembering vexation.

The woman on the television with eyes filled with a mood of ill will is

flickering the luster

of scissors held

in her left hand.

No matter how much time passed the luster of those scissors wouldn't

leave my mind.

The luster of the scissors is swirling around inside my brain.

In essence the luster of the scissors is swirling around inside my brain.

I lost my focus and there was no longer anything I could do about it so

I went to the nearest wholesaler who would sell me anything

and bought a metal bat.

Then I went to the home of a friend who will do anything if there is a

demand for it

I handed over the metal bat

"Please send my head flying off with a full swing," I begged.

Without hesitation

The face of my friend taking a full swing was like the suction cup.

さよならハサミの・・

用意周到に惰性で　ありふれた土曜
何度となく苛立ちを覚えたりした日のこと。
心もち敵意に満ちた目の女がテレビの中で　左手に持ったハサミの光沢を
ちらつかせている。

何時間経っても　そのハサミの光沢が俺の頭から離れなかった。
脳内をハサミの光沢が渦巻いている。実質　脳内をハサミの光沢が渦巻い
ている。

気が散って仕方がなくなったから　俺は何でも売ってくれる最寄りの問屋
へ行って
金属バットを手に入れたりした。

それから需要があれば何でも供給してくれる友人宅に行って
金属バットを手渡し
完全なスイングで俺の頭を吹っ飛ばしてくれよ　と哀願した。

躊躇なく
金属バットでフル　スイングする友人の顔つきはタコの吸盤の様だった。

My younger brother doesn't say much. I think that in itself is a wonderful thing. Even though my brother is turning thirty-two he only eats that variety of snacks called junk food sneering all the while. Even though he has a slovenly face there is a certain sharpness in his eyes. It is not a disagreeable sharpness; somehow his eyes have a sharpness in which reliability can be sensed. I confirm that reliable something in my younger brother's eyes and I go out to work. It's always like this. His eyes pat me on the back. Now and then my younger brother stabs me in the back with a fruit knife. Because of this my back is covered with wounds. If you have the opportunity please look at my back. It has an abundance of dignity. I think that in itself is a wonderful thing.

Fevers

My younger sister matured early. When she was four she was so in
love with jazz she almost died. When she is in love her eyeballs are
reminiscent of marbles. She took her grandfather's fountain pen,
"The wave of fancy deadly poison is reaching a climax,"
this she wrote in her picture book
relying only on her intuition.

わたしの弟は口をきかない。それはそれは素晴らしいことだとわたしは思っている。弟は三十二歳になるのにジャンクフードといわれる類いのお菓子ばかり食べて　にたにたしている。だらしのない顔なのに　目の中には何かしら鋭さがある。嫌な鋭さではなく、何か頼もしさの感じられる鋭さがある。弟の目の中の頼もしい何かを確認して　わたしは仕事に出かける。いつもそうだ。弟の目がわたしの背中を押す。たまに弟はわたしの背中を果物ナイフで突き刺したりもする。なのでわたしの背中は傷だらけだ。機会がありましたらわたしの背中を見て下さい。とても貫禄があるんです。それはそれは素晴らしいことだとわたしは思っている。

発熱

妹は早熟だった。四歳のときにジャズにときめいて
死にそうになったことがある。ときめいている時の
妹の目玉はビー玉を思わせる。妹は祖父の万年筆で
「ファンシーな猛毒が最高潮に達している」と
勘だけを頼りにお絵描き帳にそう書いた。

Open Your Eyes

Open your eyes
the twins are attempting to
cut down our skyscraper.
The twins aren't *children.*
With an axe that precludes stagnation
the twins are attempting to cut down our skyscraper.
Bit by bit my mind grows deranged,
4 times in 1 day my mind grows deranged,
6 times in 1 day I eat *sekihan* rice,
such as "in any case your testicles are your native land"
such as "in any case your asshole is god"
muttering, and not muttering these things,
the twins are attempting to
cut down our skyscraper.
While savoring that excitation called tragic fate
right out in public our skyscraper is being
cut down.

めんたま あけろ

双子が　わたしたちの高層ビルを

切り　倒そうとしてる。

双子は　コドモじゃない。

停滞を　許さない斧で

双子が　わたしたちの高層ビルを

切り　倒そうとしてる。

少しずつ　頭おかしくなって、

1日に4回　頭おかしくなって、

1日に6回　赤飯を食べて、

「なにしろ　お前の睾丸は祖国だ」とか

「なにしろ　お前の尻の穴は神様だ」とか

呟いたりして、呟かなかったりして、

双子が　わたしたちの高層ビルを

切り　倒そうとしてる。

悲運という　興奮を味わいながら

公然と　わたしたちの高層ビルは

切り　倒されるのだった。

Visited

The measure of pain to injury is not always in proportion.

The mouth of my open wound is wrapped in a luster like an oil slick,

from shoulder to knuckles it is bursting open yet

there was no pain.

Reflected in the contact lenses adhering to Miya Shiro's eyeballs

was my wound.

"Now, let's sing a song about wounds," said Miya Shiro.

"I don't sing," I said.

His forelocks are undulating in a cool breeze.

"Suppose

that yesterday, both my hands were chopped off, and then just a moment ago

both my legs were chopped off,

then tomorrow, my skin and some or all of the whatnots inside my body were to

be torn away, my brain would probably still be there floating in space

as if nothing had happened at all.

Even if my brain floating in space were to be captured and incinerated,

my consciousness will fly to Tahiti and would probably be leading a life of

leisure and mellow," said Miya Shiro.

"I'm not interested," I said.

My wound that had had no connection to pain hurt just a little.

訪問される

いたみと傷の程度というのは　かならずとも比例しない。

私の傷口は油膜のような光沢を帯びていて、

肩から手の甲にかけ　ぱっかりと開き切っているが

いたみはなかった。

宮史郎の目玉に貼り付いてるコンタクトレンズに映っているのは

私の傷口だった。

「さあ、傷口の歌を歌いましょう」と宮史郎は言った。

「私は歌いません」と私は言った。

すずしい風が宮史郎の横髪を揺らしている。

「昨日、両うでがちょん切られて、ついさっき両脚がちょん切られたとする、

それから明日、皮や 体の内側の何やかや全部　剥ぎ取られたとしても、

アタシの脳みそは　何事もないように宙に浮かんでいるだろうね。

宙に浮いた脳みそが捕まえられて焼却されたとしても、

アタシの意識はタヒチに飛んで　悠々自適でメロウだろうね」と宮史郎は言った。

「私は興味ありません」と私は言った。

いたみとは縁のなかった傷口が 少し痛んだ。

I saw a vision of my *sister* squishing *hamachi* sashimi in her hand as she teleported through space. My *sister* had an expressionless face. My *sister*'s clothing is made out of fish scales. The clothing made out of fish scales reeked of fish. From gaps between the scales a low pressure system emerged. The low-pressure system continued to emerge as if it were completely drunk and tumbling down the stairs. It was a low-pressure system that emerged bound up with resignation and utter spinelessness. It was a low-pressure system that smelled of pencil lead as if to evade all eyes. It was in some way tepid and completely smelled of pencil lead to the point where you would even find it conscientious. The smell of pencil lead was my *sister*'s accomplishment. My *sister* had an expressionless face. My *sister*'s clothing is made out of fish scales. The clothing made of fish scales reeked of fish even more. The smell of fish and the smell of pencil lead commingled and smelled of briar roses. The smell of briar roses is also my *sister*'s accomplishment.

A Firmly Clasped Hand

I am looking through your body and beyond you.

In spite of this I know nothing of *your* bruises bleeding

sweat drool.

Every day, every day, every day, night comes.

Night is the burnt cinder of *your* or my excretions.

Time passes unrelentingly.

Only the passage of time was impartial.

I only remember *your* last sigh.

Everything is that everything is nothing more than a product.

I think that

even *your* last sigh is nothing more than a glittering product.

How should I say it I think so in a good way.

はまちの刺身を握り潰しているシスターが空間移動するというビ
ジョンを見た。シスターは無表情だった。シスターの私服はうろ
こで出来ている。うろこで出来た私服は魚臭かった。うろこの隙
間隙間から低気圧が発生している。ベロンベロンに酔っ払って階
段から転げ落ちる様に低気圧が発生し続けている。諦めや不甲斐
無さがない交ぜになって発達する低気圧だった。人目を忍ぶよう
にエンピツのシンの匂いがする低気圧だった。何か生ぬるくて良
心的にさえ思えるほど完璧にエンピツのシンの匂いがする。エン
ピツのシンの匂いがシスターの成果である。シスターは無表情だ
った。シスターの私服はうろこで出来ている。うろこで出来た私
服は更に魚臭かった。魚の匂いとエンピツのシンの匂いとが入り
混じって芳ばしい野ばらの匂いがした。この野ばらの匂いもシス
ターの成果である。

固い握手

わたしはアナタの体を透かして向こうを見ている。

アナタの打ぼくや出血のことも

汗のことや　よだれのことも何も分かっていないのに。

毎日、毎日、毎日、夜が来ます。

夜は　わたしやアナタの分泌物の黒い燃え殻です。

時間は容赦なく経過して行く。

時間の経過だけが公平だった。

わたしはアナタの最後の溜息だけを憶えている。

全部が全部は生産品にすぎない。

アナタの最後の溜息も　きらびやかな生産品にすぎないと思っ
ている。

何ていうか　いい意味で　そう思っている。

I remember it well. Touching it any number of times. Touching as I want to touch. There is no reason why you would know everything, but you will consume it. From the start there is no such thing as a safe place. As a physical sensation I amplify. The essence of exercise. Becoming enraged just a bit. Blinking or manner of breathing. Touch and the like transform. There is no need to reach maturity. I think that thing maturity is merely boring. We can be stoic and missing persons. m a n u a l things *make me feel sick*, like I'm about to spew vomit. Good morning, love and fiction. Everything from start to finish is sure to be fiction. Where and when would you say is not fiction? In spite of that everybody is a damn creation. Place fiction in your eye, emit love from your mouth. Philanthropy. Puke up love. Utterance. Pronunciation. I want to share it. Strangely vividly, I have a premonition of a relationship. Curvature and the like, desire and the like. Enchanted with swollen desire, our wounds open. Ruptures. Ruptures so liberating they blind the eyes. Realizing that the more sincere you become the more meaningless you become. Something everybody knows, I suppose. Not looking away is the means. The skill of playing with meaninglessness. Consciousness and technology. Playing with superstition or layout. Playing with listlessness or the intermingling of business and personal affairs. Playing with reflexes or acts of exchange. Playing with suspension in midair or briefly exposed bright extinction. Everything, has an end in everything. Reconciliation or reverence to the fact that everything will absolutely be annihilated. Good day goodbye, we have this fabricated undefended time zone. Repeat. We all go to this fabricated undefended time zone. Stay just like that forever and please do not mature.

引きちぎれる開放感のフレーミング

よくおぼえている。何度でも触れること。触れたくて触れる。すべてがわかるはずないし、消耗してしまうけど。始めから安全な場所なんてものはない。私は身体感覚として増幅する。運動の質。少しキレてみたり。まばたきや息づかい。手触りとか変形。別に成熟に到達しなくていい。成熟なんかは退屈なだけだと思っている。私たちは平然と行方不明になれる。manualってキモチワルイ、ゲロが出そうになる。おはよう、愛とフィクション。なにからなにまでフィクションに決まってる。どこのどいつがフィクションじゃないっていうの？全員が作り物のくせしやがって。フィクションを目に入れて、愛を口から出す。博愛。吐く愛。発声。発音。分け合いたい。変に生々しく、関係を予感している。湾曲とか欲望とか。肥大した欲望に　うっとりして、私たちの傷口が開く。裂け目。目がくらむほど開放的な裂け目がある。切実になればなるほど無意味になることも知っている。多分、誰でも知っている。目をそむけないことが手段。無意味を遊ぶスキル。意識と技術。迷信やレイアウトを遊ぶ。倦怠感や公私混同を遊ぶ。反射神経や交換行為を遊ぶ。宙吊りやベロリと露出した明るい消滅を遊ぶ。全部が、全部には終わりがあるっていうこと。必ず消滅するっていうことへの折り合いや敬意。こんにちはさようなら、私たちが ねつ造したこの無防備な時間帯。繰り返し。私たちがねつ造したこの無防備な時間帯へ。そのままいつまでも成熟しないでいて下さい。

A Staircase Landing

A staircase landing, now, and then, hello, before we get to it, that is to say, I destroyed a television that resembled a small animal, armed with a saber, presently, I am eating grapes at the kitchen table,

if you have the opportunity, I decorated the walls with illustrations of bats, without a break for a long time, the inside of the house was a compressed landscape, as usual, from my knees to my ankles there is a gash and there an animal called a bird had been hiding, one could say that I am the bird's possession,

there was nothing impending, aimlessly, for some reason it felt good, for a short while, I wound a clock, and then toward the door, I turn, from the beginning, it had made sense,

just as I had imagined, the bird rolled over, curled up △d tried out various postures, tossed and turned with abandon, and as if mirroring the bird I opened, the door, and pivoting on one foot changed the direction of my body, while turning cartwheels and backflips and the like I disappear from home, and with the attitude that the stupid should be caused to die the bird is, sleeping, disappearing from home was a kind of eyesight, without difficulty within arm's reach, a vibrant eyesight

Example

In the deep night while moment upon moment

girding up in fictions

the surface is ill at ease. In exchange for something

sometime when fruit came to bear

a snail would secretly shed its shell and become a snake

and that snake would be pregnant with red fruit.

踊り場、いま、それで、もしもし、取りかかる前に、すなわち、小動物に似たテレヴィジョンは壊した、サーベルを身につけて、今どき、台所のテーブルで葡萄を食べている、

機会さえあれば、壁にはこうもりのイラストを飾った、休みなくずっと、家のなかは圧縮した風景だった、例によって、私のひざから足首まで裂け目があって鳥という動物が隠れていた、私はいわば鳥の所有物である、

差し迫ったものはなかった、無目的に、何となくいい気分だった、少しのあいだ、時計のねじを巻いた、それからドアに、向かう、始めから、理に適っていた、

思いついたままに、鳥は寝返りを打った、まるくなったり△になったりいろんな姿勢を試して、寝相に糸目はつけなかった、それに見合うようにドアを、開く、片足を軸にして体の向きを変え、側転やバック転などをしながら私は家出する、馬鹿は死なせたほうがいいという態度で鳥は、眠ってる、家出は一種の視覚だった、難なく手の届くところに、鮮やかな視覚

例

夜更け刻々と虚構を帯びながら

表向きはしらけている。何かと引き換えに

いつか果実が果てたとき

かたつむりは　こっそり　殻を脱ぎ捨てて蛇になり

その蛇は赤い果実を妊娠していた。

278

An Old Person

I think I was lighting off fireworks. A ground spinner was spark

ing. Everybody and that particular man and everybody else was awful too.

Even the parasols.

The lies too. And the viewings. And the anarchists. And the tape recorders were

also absolutely

awful. Noon destruction? There isn't even sane destruction.

If the contact points of tender kisses are also awful then. Eight seconds

later they were still awful. Because they are awful I am going out to buy some

clothes. I am going out to buy some *cruel* and cowardly clothes.

老人

花火をしていたような気がします。地面にかげろうが立ってい
まして。みなさんも　あの人もその他誰でも最低でした。　　日傘も。
嘘も。鑑賞も。アナーキストも。テープレコーダーも実に最低でし
た。　　　正午の破滅？　正気な破滅　すらない。

接吻の接点も最低なら。　　8秒後も最低でした。　最低だから服を買
いに行く。ザンコクで臆病な服を買いに行きます。

Soutaro

Ultraviolet rays streamed in
a rollercoaster ripped apart and killed a seagull.
"What are you doing now?"
The long awaited telephone call from her came through.
"I've been pondering the loss of physical functionality,"
he said in a voice like iron.
His voice is far more analogous to iron than his appearance suggests.

"It's foolish to want to know things you don't need to know,"
she said and hung up the telephone in a physiological manner.
"Yes it is foolish to want to know things you don't need to know,"
he said in turn and hung up the telephone.

Stubbornly he naps in a correct posture
without any circumstances beyond his control, he watches his dreams.

In his dreams he was iron itself.

Choosing

I was reading an extremely lonely picture book

They were picture books without even so much as names

The picture book radiated a soft heat

A boy was dancing ballet in the womb of a whale

The boy was always alone

There was nothing to cause a sense of loneliness

Yet he was utterly alone

Longingly waiting his body and spirit continued to dance

奏太郎

紫外線がそそがれて
ジェットコースターがカモメを轢き殺した。
「いま何してるの?」
お待ちかねの電話が彼女から掛かってくる。
「身体機能が失われることについて考えていた」
と鉄のように彼は言った。
見かけよりずっと彼は鉄に類似しているのだ。

「知らないでいいことを知りたくなるのって阿呆だよ」
と彼女は生理的に電話を切った。
「知らないでいいことを知りたくなるのって阿呆だね」
と彼は次第に電話を切った。

あくまで姿勢正しく仮眠して
彼はやむをえぬ事情もなしに夢を見るのだ。

夢の中で彼は鉄そのものだった。

選択する

いとも孤独な絵本を読んでいた

名前すらない絵本だった

絵本は柔らかい熱を放射していた

鯨の胎内で男の子がバレエを踊っていた

男の子はいつもひとりだった

寂しさを感じさせるところはなかった

ただ、とてもひとりだった

待ちわびて身も心も躍り続けていた

Artificial Flower Skin

Planted in a large pot, a showy

floral-print kimono had

already begun to wilt smelling so sweet

it was nauseating. Just as I had thought poor

people gathered before my house,

a lone goldfish seller tried to cut through

the crowd. While he was shouldering a pole with a wooden

bucket with goldfish inside, swinging it left and right

as he advanced, I

had a strange feeling

as though I myself had become the goldfish seller, and while cry

ing out I seized 1 goldfish floundering in the space

between the feet of the crowd.

Play Synthesis

Going to the sea with my wife and child

on a Sunday in August, the two of them sketched my life

as an arc and handed it over,

two miniature horses

giving off a soft light,

rode onto my arc, and later

the smell of rubbing alcohol

lingers slightly,

the child soon crammed

the horses that had finished riding

into the pocket of his swimming trunks, and kissed

a curling lock of my hair,

inside the pocket of his brand-new swimming trunks

was the sound of those two horses being smashed,

造花肌

大きな鉢に植えた、派手な

花模様の着物は

すでにしおれ　胸が悪くなるほどの

甘い匂い。案の定　家の前には貧

しい人々が集まり、その人だかりを

突っ切ろうとした一人の

金魚売り。金魚売りが天秤棒に金魚の

入った桶を担いで、左へ右へと

揺れながら突き進むうち、わた

しは自分が金魚売りになっている

ような妙な気分となり、わめきな

がら人々の足の間で跳ねる１ぴきの

金魚を捕まえた。

合成ごっこ

女房子供たちと海へ出かけている
八月の日曜、ふたりは 私の人生を
曲線で描いてよこした、
柔らかい光沢を放つミニチュアの馬が
二頭、私の曲線を駆けて、あとにかすかな

消毒用アルコールの臭いが残る、
子供は駆け終えた馬をすぐに自分の
海水パンツのポケットに突っ込んで、私の
つむじにキスをした、
真っ新の海水パンツのポケットの中で
二頭の馬が潰れて音をたてた、.

Habit

The place I'm at right now is on the north side of the lodge

and I can see two stars in the sky. Beautiful.

Women wearing polka-dot-patterned dresses

approached with pistols in their hands.

Sparrows were perching on the shoulders

of most of the women.

"I wonder which one is the Queen?"

I had been musing on such a topic.

Even though they are carrying pistols

the women are very social

and create the atmosphere of a fun idle conversation.

They danced

and fooled around.

Most of the women

sleep with their eyes open.

My Grandfather Is Drama Itself

I entered my carriage and departed for a luncheon

A blindingly bright spacesuit had fallen in the middle of the road

The coachman picks up the spacesuit and lays it aside

As he does this my uncle is sleeping underneath

His sensitive nose sniffs out a familiar smell

My grandfather awakens

then calls me on the telephone

"Would you like some cookies?"

I responded with my usual smile

A cookie wrapped in a thick, round leaf passed

from my grandfather to the coachman

From the coachman it was passed to me

More than anything

my grandfather's cookie tastes wonderful

My grandfather carried the spacesuit

and began to walk

Then he calls me on the telephone

"I hope we meet again"

習性

私の今いる場所はロッジの北側で

空には星が二つ見える。美しい。

水玉模様のドレスを着た女たちが

拳銃を手に近づいてきた。

女たちのほとんどの肩に

ツバメがとまっている。

"誰が女王なのだろうか"

私はそんなことを考えていた。

拳銃を持っているにもかかわらず

女たちは社交的で

楽しい雑談の雰囲気がある。

ダンスをしたり

ふざけ合ったりした。

女たちのほとんどは

目を開けたまま眠る。

祖父は劇です

馬車に乗って昼食会へ出掛けた

道中にまぶしい宇宙服が落ちていた

騎手は宇宙服を持ちあげ脇へ置いた

するとその下に祖父が眠っている

鋭敏な鼻がなじみの匂いをかぎつけ

祖父は目を覚ました

そして僕に電話をかける

「クッキーでもどうかね」

僕はいつもの笑みで応じた

厚ぼったい丸い葉に包まれたクッキーが

祖父から騎手へ

騎手から僕へと手渡された

祖父のクッキーは

なによりも味がよい

祖父は宇宙服をかかえて

歩きはじめた

そして僕に電話をかける

「またどこかで」

Falling Forward Slightly

Falling forward slightly I came upon the park I was fond of, the altogether chintzy sandbox even now lacked a sense of solidity. Unexpectedly sirens blare. The sirens had been given so much thought that they could pass for pop music; they were sirens that resembled even delusion and satiety. This was the first time I had ever heard a siren that was so unlike a siren. I was just hoping that it was nothing at all. Nevertheless I've got a physical nature that prefers action and is not suited to merely hoping. More impatient than ever I came upon the park I was fond of, the altogether slapdash sandbox even now lacked a sense of solidity. It has the atmosphere that no matter what happens it won't matter at all. Truly no matter what happens it won't matter at all. One after another children serenely began to play in the sandbox. The sight of them playing with the sand filled my sight their play in the sand was absolutely incorrigible. The children looked like fragments and crowns. Every last one of them was seizing a rainbow in their eyes. I hear that they take them home and fall asleep with them.

I Don't Sympathize

I gazed at sausages and carrots and lesbians

as if they were a collection of absurd love.

A scene that exuded tender care.

I see it clearly.

In the distant future every one of our *bodies*

without exception will not remain

and will become nothing more than a tale of old. Or

a game where the *fuckers* who drop dead are the losers.

A loss was a loss. If viewed in the long run

everyone had been losing. In spite of this

we are excited in the midst of despair.

As the era in which anything stimulating is great was over

let's go take a look at the spot where love collapsed.

Bring along a tambourine and a sleeping bag and a tennis ball and racket.

In this world of the end of days let us play tennis.

In this world equivalent to a global shit

tried and true tennis

that both ourselves and others would probably accept.

同情しない

ばかげた愛の集まりのように

ソーセージと人参とレズビアンを眺めた。

思いやりにあふれた景色だった。

ちゃんと見えている。

のちのちに私たちのカラダは皆一人残らず

昔話になってしまう。もしくは

くたばったヤツが負けのゲーム。

負けは負けだった。長い目で見たなら

全員が負けていた。それでも私たちは

失意のうちワクワクもしている。

刺激的でいいのだという時代は終わっていたから

さあ愛が崩壊した場所を見に行こう。

タンバリンと寝袋とテニスボールとラケットを持って。

終末の世間でテニスでもしましょう。

グローバルな糞と同等の世間で

自他ともに認めるだろう筋金入りのテニスを。

やや前のめりに懐かしい公園を見つけて

やや前のめりに懐かしい公園を見つけて、徹頭徹尾チャチな砂場は あたかも立体感の欠けた砂場だった。思いがけずサイレンが鳴っている。ポップスたり得る配慮がなされたサイレンでして 妄想と飽食にも似たサイレンだった。こんなにもサイレンらしくないサイレンははじめて聴きました。何事も無いことただ願うばかりだ。それにしても願うばかりというのは性に合わない実行優先の体質である。歯痒さこの上なく私は懐かしい公園を見つけて、徹頭徹尾テキトーな砂場は あたかも立体感の欠けた砂場だった。なにがあってもどうってことないたたずまい。ほんとうになにがあってもどうってことないのだ。つぎからつぎ余裕綽々の子どもは砂場で遊びまくり。私の視野を埋め尽くしてしまう砂遊びでして 全く手に負えない砂遊びだった。破片と王冠にも似た子どもだった。ひとりのこらず皆は 眼の中に虹をつかまえていました。家につれ帰っていっしょに眠るのだそうな。

From where do I begin to write/blindly I was a goldfish seller/I sell pure yellow goldfish that my acquaintances have/I sell as many as I can/I am simply selling them/and I don't know a thing about pure yellow goldfish/I have never thought that I particularly wanted to know/the lot who come to buy pure yellow goldfish all of them as if they were insane buy up as many of those pure yellow goldfish as they can and leave/maybe they are keeping them as aquarium fish I don't know/maybe they happily swallow those pure yellow goldfish/anyway the pure yellow goldfish sell well/even if I had my eyes closed they would still sell well/the days pass by uneventfully/it was merely that I had good luck/acquaintances are nothing more than acquaintances/they don't have names/we met seven years ago/I was watching *Starship Troopers* at a movie theater with my lover/when the front legs of a giant insect skewered the body of a female soldier/a man in a nearby seat stood up/that man looks like me/it was as though I were seeing myself objectively/I felt strange/the man soon sat back in his seat/when the female soldier died he was weeping/ the man wiping his tears/didn't want to be seen by anyone/my lover lightly tapped the area around my knee/I look at the crying man as to exchange glances/I became truly ashamed/even after we had finished watching the movie a strange feeling persisted/I wanted to talk with that man/it was he who initiated the conversation/point blank/because he said, "I am sorry to be so abrupt, but I am a goldfish seller could I have you help me sell goldfish starting tomorrow"/"If it's alright to do it as a side job"/"Of course doing it as a side job will work out fine, I hope you will accept"/the man looked absolutely nothing like me/my lover was giggling/the man had no name/from the next day onward I was selling pure yellow goldfish/they would sell even if I had my eyes closed/they sell themselves/

アシ／

何から記録する／盲目的に私は金魚屋だった／知人の持っている真黄色の金魚を／私は売れるだけ売る／単に売っているだけ／真黄色の金魚のことは何も知らないし／別に知りたいとも思ったことがない／真黄色の金魚を買いに来る連中はどれも狂っているみたいに　真黄色の金魚を買えるだけ買って行ってしまう／観賞魚として飼っているのかも私は知らない／連中は真黄色の金魚を楽しげに食べるのかもしれない／とにかく真黄色の金魚はよく売れる／目をつぶっていても売れていく／毎日は平々と過ぎている／私は運がよいだけだった／知人は知人以上のなにものでもなく／名前が無い／私たちは七年前に知り合った／私は恋人と映画館でスターシップトゥルーパーズを観ていた／巨大な昆虫の前足が女兵士の体を刺し貫いたとき／近くの席の男が立ち上がった／その男は私に似ている／客観的に自分を見ているようで／変な気持ちになった／男はすぐに席に着き直して／女兵士が死んでしまうと泣いていた／涙を拭うその男を／誰にも見られたくなかった／恋人が私の膝辺りを指で小さく叩いて／泣いている男を見て　という目配せをする／私は本当に気恥ずかしくなった／映画を見終えても何か変な気持ちが続いて／私はその男と話がしたかった／話しかけてきたのは男の方からだった／単刀直入に／「唐突に申し訳ありません、僕は金魚屋なのですけど　明日から金魚を売るのを手伝ってもらえませんか」と言うので／「片手間でいいんでしたら」／私は気楽に請け合った／「もちろん片手間で結構です、お願いします」／男は私とは全く似ていなかった／恋人は微笑んでいた／男の名前が無かった／私は翌日から真黄色の金魚を売っている／目をつぶっていても売れていく／独りでに売れていく／

Nihongo/Nihon
The Japanese language. Within Japan, "Japan" is referred to by the word "Nihon" and the Japanese language by the word "Nihongo." The first written use of the word "Nihon" is considered to begin with the legendary Crown Prince Shōtoku Taishi (574-622), who explained in a diplomatic communication to Emperor Yang of Sui (569-618) during the Tang Dynasty that Japan was to be known as "the place where the sun rises."

Jōmon
The period of Japanese prehistory between approximately 14,000 BC and 300 BC, characterized by the use of stone tools and various decorative motifs applied to ritual figures, implements and decorative items. Jōmon also refers to the pottery of that period, hence the name. Jōmon pottery is some of the oldest yet discovered anywhere in the world.

Kushisashi
A form of Japanese cuisine where morsels of meat and vegetables are skewered and cooked. Refers figuratively to anything speared/skewered.

Washitsu
An architecturally Japanese space, generally containing decorative elements such as a floor composed of tatami mats, a ritual alcove known as a tokonoma, translucent shoji screens and fusuma that provide privacy and form to the space. These rooms are generally reserved as bedrooms and space for relaxation. They are often the one Japanese room in otherwise Westernized homes.

Tekkamaki
A cuisine based on cooking food on a hot iron grill. A chef usually cooks in front of the customer a variety of ingredients, including vegetables, meat and fish.

Irezumi
A traditional style of body-covering tattoo most often seen on yakuza.

Tanka
A form of modern Japanese short form verse, consisting of the pattern 5-7-5-7-7 syllables, or morae.

Shōchū 189
A form of Japanese hard alcohol brewed from either fermented potato or wheat.

Shishamo 189
Japanese smelt, specifically Spirinchus lanceolatus. Shishamo can also refer to any small silvery fish eaten grilled and either salted or with a light battering of flour, usually eaten for the eggs that fill the small, meatless bodies.

Tamori 189
The comedian Kazuyoshi Morita (1945-). He is known for wearing sunglasses all the time, no matter what.

Yuba 235
A style of tofu prepared by skimming the top, congealed, tender layer from heated soymilk. Generally known as "tofu skin."

Sekihan 257
Rice cooked with azuki red beans, giving the grains of rice a mauve to red coloring representing blood and alluding to the auspicious nature of life and vitality. Usually eaten with gomashio, a mixture of black goma seeds and salt. While traditionally eaten at festive occasions such as birthdays, holidays and when a young woman reaches menarche, it is also enjoyed commonly in bento boxes and as a dish prepared at home.

Miya Shiro (1943-) 261
A singer of emotional ballads known as enka. He released Otoko no Hanamichi on his own and has sold four million copies. With his moustache and melodramatic glamour, he embodies the art of enka.

Hamachi 262
Seriola quinqueradiata, known colloquially in the West as "yellowtail." Eaten cooked or raw.

Let's Talk About What We're Really Talking About
David Michael Ramirez II

"Because death is nothing but a *son of a bitch*."
——"Molotov Cocktail" Henguchi Yoshinori

Translating and, if I may borrow a term from film production, "co-producing" *Lizard Telepathy Fox Telepathy* has brought rewards and experiences beyond anything I could have initially imagined.

And why should anybody care?

Why should anybody care when somebody chooses creativity as the means to stand up and fight? Why should anybody care when that creativity fights for literary truth and subsumes the normal rules of representation? Why should anybody care that Henguchi Yoshinori has come out of the collective blind spot of the Japanese imagination and conscience called "*Osaka*" (which many Japanese claim to be almost "another country") to represent lyric creativity for an entire *language*. Why should anyone care that Henguchi explodes through cultural walls using photography, literature, visual and linguistic metaphors, and pushes *Nihongo* beyond both external and self-imposed boundaries? And why should anybody care that his creative works prove once again, even in translation, that language can be something more than merely a vehicle for social contracts and expectations, a beast of burden, a simple carrier of information and convention, filled with mundane platitudes and worn-out, second-hand prejudice and presumption? Why should anybody care that there is a voice of reason that has chosen creative expression to smash the falsehoods of empty promises through the sheer force of imagination, destroying the fear of life, awareness and consciousness in its wake?

The fiery challenge to usurp expectations, to burn away the façade of an eternally cumbersome and socially imposed status quo of communication to reveal a more refined façade and the eternal present is Henguchi's artistic declaration of war. And yet, in this he leaves the reader with a renewed sense of self and a far more open sense of reality. He gives the reader an imagination primed to think beyond their limitations, self-imposed, other-imposed, or otherwise. Henguchi's poetry is the fight for literary liberation that I have been interested in for a long time. Henguchi begins this fight by describing his native language to the point where,

for his own present moment at least, he forges a new appraisal of *Nihongo* as a language of timeless and intense creativity. We should all be so lucky to voice such an appraisal in our own lifetime. My hope is that as readers experience his artistic vision, they too embark on a voyage of consummation, and can begin to undertake such a task.

I was searching for such a beginning when I met Henguchi Yoshinori in Osaka in 2008. My gaze, seeking this artistic fight, was immediately captured by his artwork during a chance visit to a club called *sansui* in Shinsaibashi, Osaka, for its tenth anniversary party. In the middle of a parade of much louder video art, performance art, live bands and late-night indoor smoking and drinking, *Nihongo* was there. In its original self-published letter-sized paper format, it stood silently in its original 9' x 6' format on a wall. It was not clear where it began or where it ended. Portions of it could be read at a glance and yet they still had immediate impact. This impact did not end at a certain point. No matter where I chose to read from that wall of poetry, I came away with something amazing. It was as if Barbara Kruger had mated with Gertrude Stein and Henguchi Yoshinori had become their love child. To my sense of literature, nothing could be better. He was there that night and we met. And from that day onward, I embarked on a personal mission to produce translations worthy of his finely crafted expressions. In his poetry alone he became the ally in the fight I had been looking for.

For our initial discussions, Henguchi took me on a short trip to see his photography on exhibit at Contemporary Art Space Osaka. This was a location I had visited before, but only briefly. It was near beautiful brick warehouses by the Port of Osaka, close to the middle of nowhere and the sea. I was happy to be there again. Once we arrived, he gave me a challenge: "Guess which works are mine." All the photography in the exhibit was unlabeled, so I had no choice but to make guess after guess to see which ones might be his. Some of the works were raw and carnal, such as one series of black and white photos of a Japanese woman having sex with an African-American soldier in a love hotel. "These pictures were taken by her daughter," he told me. Others were more or less colorful and active, and I made thorough attempts to identify the photographs that were his. "These ones?" "No, not those." "How about these?" I thought, picking out the works of another artist who had some sense of contemporary excitement in his or her work. "No, not those, either," and so on I made my way through the exhibition space.

In the last section of the exhibit, on the wall, I found a group of photos that had me burst out in excitement. "Look, [*dammit!*]" scrawled in spray paint on a metal wall. A door around a doorknob. Sesame-seeded buns illuminated from above by a suggestive light (seemingly divine or from a UFO). A strange combination of a sign that read "hotel" and a pine branch indicative of virility, potted plants and people barely managing to fornicate indoors. Every photo was bursting with more than tongue-in-cheek innuendo. Everyday objects lustily protruded in juxtaposition with sacred and divine objects. The message was one of ordinary vitality that was usually hidden away out of a sense of hygiene and despair. All of these images were a semiotic assault on typical sensibility. And together they composed an elaborate strategy of conspicuous exaggeration to both undermine and celebrate presupposed expectations of a *depressing* material order. All of Henguchi's visual commentary on such depression was done lovingly. The photographs were set in gold-colored baroque frames, as to prove his point. This was the same type of appreciation that Beck had for the petty but saccharine excesses of urbane life in his album *Midnite Vultures*. All of Henguchi's subjects were so riotously askew. Normally "meaningless" objects had been transformed by his touch and now penetrated through the fog of everyday thoughtlessness. I burst out laughing as I perused his photos. "It's good to know that my work can be understood from somewhere else," he said. "By someone else, from another country, like you. I'm really glad you can get it. That's encouraging."

For the rest of the day we walked through the Shinsekai neighborhood near Osaka's "other" downtown. I watched him take shots that sparked his photographer's eye. And at the end of that trip, as we parted, he said, "Here, I have a gift for you. Please take this." It was an original loose-leaf edition of *Nihongo*, as well as a collection of about twenty other poems. I knew this would be the beginning of something new.

As I began to read more and more of Henguchi's poems, I found the same degree of instantaneous impact as there was in his photography — a raw power that sparked the reader's imagination. His poetry was visual, synesthetic, and it followed none of the pseudo-pedantic rules of how reality should be "linearly" portrayed. How does one exactly turn *Nihongo* to smoke? What exactly is "*Nihongo* like a festering wound"? Inside of his works there is inner truth revealed, appreciated and given beauty without regret. From his open admission of a chaotic life teeming with order, I found a feeling of expansion, something akin to the thrill of live music that can liberate your mind and energize you

instantly. This thrill —something akin to Brian Eno's "Needle in the Camel's Eye" or Miles Davis' *Bitches Brew* or Beck singing in falsetto against syncopated rhythms in "Peaches & Cream," the beginning and end of David Bowie's "Ziggy Stardust," or the somewhat awkward drums of Sakamoto Ryuichi and David Sylvian's "Bamboo Houses" — kicked off the journey to the publication of this translation. I had no idea how long this journey would take, or who would become the collaborators that brought Henguchi's special vision of language to form.

I was lucky to meet our publisher early on, Bruce Rutledge. Bruce understood the unique mission and power contained in *Nihongo* and Henguchi's poems, as well as their international context. Guided by Bruce's imperative to publish books that define the present moment, both aesthetically and substantially, Henguchi, Bruce, and myself began by co-curating Henguchi's poems, and *Lizard Telepathy Fox Telepathy* began to take form. After months of private review, on a cloudy but sunlit afternoon in Fremont, Seattle, Bruce and I met for coffee. Both of us brought along drafts of the translations with our comments and opinions scrawled on them. The thrill of seeing them spread over a large wooden coffee table was intense. We discussed our personal favorites, and we knew that we had chosen to confront the important message of creative vitality in Henguchi Yoshinori's poetry.

We had no choice but to make it *louder.*

After co-curating the poems, arranging them became my role. To further evoke their creative pathos, detection of their instantaneous impact was key. By tracing variations in rhythm, tempo, length, juxtaposed with their emotional, kinesthetic, and cerebral resonance, each poem found its place. Their specific arrangement and placement in sections was to create harmony among chaos, and moments for the reader to reflect and awaken to the experience of reading for pleasure, and observe the subtler notions of the act of communication itself. They evoke Henguchi's style and his ability to lead with his statements, observing entire situations with a sweeping glance. If there is any theme to be observed in the overall work, it is the struggle to recreate the energy of immediate expression despite its delivery through written language bound by the limitations and constrictions of time.

In the winter of 2011-2012 I made the decision to employ a collaborative method where the editor and I would work side by side to search for the right words.

For this purpose, along with Henguchi and Bruce, Heather Kirkorowicz and I joined together to prepare the English language translations of *Lizard Telepathy Fox Telepathy* for publication. Together we enjoyed a literary experience that felt cinematic. We edited drafts of translations in restaurants in Capitol Hill, Fremont, and South Lake Union, and from time to time in an old, large building on Queen Anne hill during times when it was occupied by only two or three. Fueled by coffee, Inka, PG Tips, green tea, wine, sparkling water, cigarettes, Irish coffee, beer, breakfasts, dinners we indulged in intense conversations about the most appropriate wording for Henguchi's Japanese in English. Both exciting and exhausting, on cold, rainy Seattle days, sometimes we pushed through the night to complete our tasks on Heather's owlish sleep cycle. In bursts and fits of time available to us we emerged from our other lives to compose final drafts. I explained the original Japanese, and together, Heather and I proposed and debated the merits of various English counterparts. In editing Henguchi's afterword, we came up with two vital words: "infinities" for 無限 *mugen* and choosing between "origin," "genesis," and later, "emergence" for 起源 *kigen*.

"Oh dear, what are we going to do with the word 'infinity,'" Heather mused.

"What do you mean?"

"If we're going to use the word 'infinity,' then we need a real expression of infinity that would refer to Cantor's sets. They explain different degrees of distance between numbers. It would be like an infinite number of spider webs where the gaps between the vertices change. In that case, we would say 'infinities,' not 'infinity.' Infinity is not some flighty Buddhist concept."

"Buddhism isn't flighty; it accepts all infinites and the distinctions among them. AND, both Buddhism and Henguchi are talking about the *real* infinite-infinity, so as you say, 'infinities' being more infinite, works. So may it be.

"By the way, Heather, can you have to look at the word 'origin'? What do you think about using the word 'genesis' instead?"

"I think 'genesis' is a loaded word."

"So is 'origin'. But what do *you* think of the word?"

"I think it's beautiful."

"Then we'll go with it."

"Done."

Months after this, the word "emergence" came to be used instead.

The fifth member of the team came aboard after we had begun editing, our amazing designer, Yusuke Shono. After seeing the first drafts of his cover

design, done in collaboration with Henguchi, I was surprised. *Lizard Telepathy Fox Telepathy* now looked and read like a book for people who read books and appreciate the aesthetics of book making. He anchored Henguchi's explosive poetry into a refined visual motif, reminiscent of the line work Japanese art is famous for with a wild, contemporary modernist streak. What started out as raw energy is now, years later, a refined literary work of art that provokes more subtly than ever.

I hope I have shared how *Lizard Telepathy Fox Telepathy* became a thrill ride of project management, artistic collaboration, artistic appreciation, and consummation of an individual and collective desire for expression. Our hope going at the start of the project was that the input was sexy, antagonistic, bold and true, and that our output would be even more so. In *Nihongo* we aimed to empower the reader to indulge in a spectacle of linguistic voyeurism. We hope to show that contemporary Japanese (*Nihongo*) has an existential virtuosity that is ready to explode into consciousnesses beyond the borders of Japan, and Henguchi Yoshinori is one of its standard bearers. We are ecstatic to have helped assert *Nihongo* and Henguchi Yoshinori's essential creativity, both as Japanese poetry and as contemporary poetry universally; we are proud because *Nihongo* is now yours too, and it is the result of a relentless and strict challenge to accurately represent Henguchi's poetry in English.

Even now, I am struck by the essential liberation of expression achieved in Henguchi's poetry. I finish reading his work feeling motivated to live and empowered to imagine, create, speak, and share. I remember my initial meeting with Henguchi, and how my encounter with *Lizard Telepathy Fox Telepathy* began in the conscious search for and belief in art that expresses optimism, truth-in-perseverance and joy. It is my sincerest hope that these forces are present for all who read Henguchi's work.

I continue to believe that the various modes and methods of the best artistic expression are obtainable only by an honest pursuit of some ultimate truth in life itself. The sincerity of this honest pursuit of life in art, and truth in life, in Henguchi Yoshinori's poetry beautifully empowers its language, both visual and linguistic. As such, the life and veracity of *Lizard Telepathy Fox Telepathy* resonates within. It taught me to see how life could lead expression, and let my heart begin anew.

Acknowledgements

I would like to give thanks to all those who helped bring this collection of Henguchi Yoshinori's poetry to simultaneous publication in English and Japanese. These people and many more who remain unmentioned helped to complete this project. They are all brave. They work tirelessly to conquer a mental and social skepticism toward art and embrace the creative achievements of the artist. Towards that end I dedicate this translation to Sae Ishikawa, for her brave and bold spirit as an artist, in gratitude for her help as a guide on the path.

Thank you to Fredric Roustan for introducing me to the works of Chris Marker, the concept of mise en abyme and Kanda Yoh, who introduced me to Henguchi Yoshinori. Thank you Dragana Spica for your artistic questioning over hours of coffee at the Osaka University of Foreign Studies and our time-warp-mini-vacations to Kyoto. Thank you Rev. Ichio Fukuda, Christine Scherbaum, Constance Carter, Joan McFarland, James Husfelt of Sacramento Koyasan, for increasing the peace and awareness in my life. Thank you Kaz McFarland, Anusha Wijetunga and Michelle Burton-Delgado for our raucous literary discussions at the McFarland home. To Rev. Imanaka Taijyo of Sojiji Temple, the Seattle Koyasan Buddhist Temple and Kongobuji, along with Rev. Yuren Tai and Noriko Tai, Haruo Kajiwara, Masako Nagano, Akiko Narusawa, Michael Thuleen and Megumi Tanaka. Thanks to the Eastside Nihon Matsuri Association, who provided me with the opportunity to meet Bruce Rutledge and his team at Chin Music Press, especially to Jessica Sattell for her constant editorial contributions. And to Rev. Koichi Barrish for the Misogi-Shuho at Tsubaki Grand Shrine, Dennis Cole, Teri Applegate and Professor Chen of Soaring Crane Qi Gong. Thank you to Area 19, for sharing your broad and ebullient Burner perspective on life. Thank you Nati Olalla, for your timely assistance and commitment to art with meaning. My appreciation goes out to the entire Queen Anne Lodge 242 F&AM of Washington and Brothers Justin Phelps Seiflein, Zane Bradley Sanderson and Eric Vogt for keeping me and this project safe, sane, housed and secure in Seattle, introducing me to Heather Kirkorowicz, the world's best editor, bar none. Thanks to my amazing teachers of Japanese language and culture who taught me how to reflect beyond ignorance and arrogance and endured my moments of both with grace and patience. Thank you to Thomas Gunterman, Kitty Shek, Shotaro

314

Hayashigatani, Yoko Hasegawa, Mack Horton, Dan O'Neill, Robin Colomb Sugiura, Marc Driscoll and Wakake Kambara, Shunsuke Okunishi, Akemi Kobayashi, Akiko Yamakage, Hitoshi Kato, Shintaro Ogami, Junko Majima and Rikiya Komei, Nagano Satoru of Gunkei and Yorozu Kyogen actor Tadashi Ogasawara. To Joel Cohn of the University of Hawaii for your advice, many, many thanks for your words of wisdom, I hope they are reflected in this work. Many thanks to my Kokufuryu Shigin instructor Shigeko Kokusei Sudo — you embody the living history of personal experience in the Pacific Northwest. To Nashika Ogami, Ayako Okano, Clinton and Yuko Godart, and Mikael Bauer for all your advice, criticism and timely philosophies. The Cybernetic Broadcasting System/Intergalactic FM, for your tireless grooves that kept my hands typing and this project going. Hanako Takeda and Tomás Wittelsbach, who taught me that being steadfast in forcefulness and sincerity of purpose means that "amateurs fuck off" is about embracing real humility and dedication. To Colin Hennigan, the love child of Lou Reed and Bruce Springsteen for turning me on to Miles Davis' *Bitches Brew* and the band Television, along with Jeff and Ginny Ballard, Ryan Mears, Devin Newell, Levi Young, Bill Portanova, David Bafus, Jon Calegari, Patrick McMillan, and Paul Klumpe for being there through the ups and downs on the way to publication. To Victor Hansen-Smith and Lorenzo Tlacaelel Lambertino for your wild creativity and blazing spirits. To Kyle Chang, Sarah Liu and Eric Heffel for inviting me to Taiwan and introducing me to Asia. To Taro Franke, Martin Nørskov Jensen, Antonio Scimone, Jon Volke, Amy Ogawa, Rodi Pau, Makenna Barris, Elizabeth Osterberg, Bryan Atwood, Lina Gonzales, Naoki Seki, Nobu Tsuzaki, Tetsu Miyabe, Koji Ito, Benjamin Hiddlestone and Mitsuko Osaki, for your inspiring endeavors, achievements, camaraderie, and teaching me to be boldly contemporary in Tokyo. To Mona Deghan, for your fiery passion and steadfast commitment to life with meaning. To Jessica Holsey for sharing your sustaining visions of fine art and California. To Anyah Hoang for your constant and forthright literary spirit. To Carmen Tamas and Rev. Shogo Kanayama of Gatsuzouji for your timely introduction to the world of Buddhism as a practice. To Casey Mochel for being a secret supporter of this work before it came to light; to Cheryl Hou, Sandra Sakai, Brett Rawson, Lynn Miyauchi and PNWJETAA for welcoming me to Seattle and for their friendship. To Akihiro Fujimori, Akira "Fajita" Takeda and Maiko Smiley, for their support, generous smiles and warmth that helped me make it to the finish line. To Travis Doty, Dan Cunneen and Alexander Larson for playing the love child of Pauly Shore and Steve Martin, along with Dana Carvey/

Charles Bronson to my Hunter S. Thompson. To the Washington Association of Teachers of Japanese for introducing me to Terry Mirande, Sandy Plann, Kazuko Howard, Patrick Cavendish and for their insights into education and entrepreneurship at Pierce College. To Tim O'Leary, at Nintendo of America for transporting me to Seattle, and the wonderful Style Savvy team led by Steven Grimm and Shino Overaa, who I thank for her incomparable all-around support and her introduction to the postmodern gentleman of the United States, Roderick Overaa. Thank you to Jie Pan, Hillary Robbeloth, Keun-Young Kim, Gao Gao, Nina Lin, Yue-Lin, Charles Randolph, Kathleen Maki, and Sadie Jensen as well as Mr. Ping, your works are "神工鬼斧", you give me so much inspiration and peace. Talael Hamzaoui for your artistic inspiration and essential philosophy and for teaching me to imagine more than the imaginable. To Said El Hirach for all your emphasis on being here-and-now. To Cafés Jam Jam, Combo and "Col" and Utena for all of your luxurious pleasures. To the Sakuda Family of Takatsuki, Japan. To Kazuhiko, Miyoko, Takayuki, Ikue, Megu, and their families: Your support in housing me for three months in Osaka while I was questing was grace itself. To my sister Elise for introducing me to Gertrude Stein's *Tender Buttons*. To my parents, Dave and Mary Ramirez, for introducing me to Miki Yoshida, my first teacher of Japanese, and for preparing me to make this book real. And finally, to Agnes Arlene Johnston-Mayo, my grandmother, who was never found without a book in her hand and understood the common-yet-misunderstood man.

装幀者のあとがき／庄野祐輔

　悲惨な出来事が続いた2011年の終わりを、僕らは傷跡の癒えぬ石巻の地にいた。そこで本の装幀の最初の打ち合わせをすることになっていたのだが、何を話したのかはもう覚えていない。しかし、成り行きのまま右往左往しながらそこで目撃したものは、何か特別な印象を残した。本の制作の過程において、それはひとつの予兆のようなものだった。

　その後、辺口さんは詩人を名乗るようになり、僕と彼は、この本を作るためにお互いの住居である東京と大阪の間を行き来した。状況の一部となりながら、そこにある混沌を認め、あるいは拒絶しながら、次の瞬間へと移動していく。文字を書くということによって、出来事が描写されていくように、僕らは移動することによって次の出来事に出会うための鍵を探していたのかもしれない。

　この本がシアトルの出版社から発売されるという事実を考えれば、そんな移動も不思議と当然と思えた。離れた場所にある距離を埋めるかのように、この本には異なる何かをつなぎ合わせる行為が必要だったのだ。

　辺口さんが運営する黒目画廊は、大阪の此花区に位置する小さな民家で、大きな川に架かる橋を渡ったその先にある。辺口さんはそこで生活をし、また生活の場を作品として展示しながら、詩を書き続けている。

　場所とそこで生み出されるものは、当然とても強く繋がっている。そして辺口さんが場所を作っているということは、詩を書くということに繋がっている。

　言葉を用いて、声を出す。それには息をするための空気が必要だ。以前、辺口さんはそんなことを言っていた。声を出す、そのために必要な空気は、自分自身で作り出さなくてはならない。だから辺口さんは、黒目画廊という場所を作った。

　それはごくあたりまえの光景かもしれない。一日をただ普通に生き延びる。新鮮な空気を探して、生きて息をする。懲りもせず出かけていき、この世界と出会う。そして、次の呼吸までの真空を、どうにかくぐり抜ける。そのようにして、詩人は声を出す。

　その声には、まだ値札も名札も付いていない。それは、ただ純粋な獣のように、ひとつの生命としてある。声は宿命として生まれた瞬間に、消え去る。しかし、その生きた痕跡を、わたしたちは火傷の痛みのようなものとして覚えている。

　このような光景を生き延びて、どこへいくのか。それは分からない。しかし、その後には、一日を生き延びたという事実だけが残る。けだるい午後を生きた確かな証。その死から詩へ転化。

　詩人の才能はいつでも必要とされている。遠回しの比喩ではなく、わたしたちが素手で世界に触れるために。詩は、常にダンスし続けている。その仕事はとても危険だが、楽しいものに違いない。たとえその試みが最後には徒労に終わるのだとしても、そもそも労働とはそういうものに違いないのだ。

Where did I come from, and where will I go?

Where did humans come from, and where will they go?

Where did life come from, and where will it go?

In the first place, what is this thing called life?

Being born, now, living, maturing,

moving, aging, dying, after dying,

before being born, what are the ancestors of humans? What are the ancestors of their ancestors?

What are the ancestors of their ancestors of their ancestors of their ancestors of their ancestors of their ancestors of their ancestors of their ancestors?

Were they monkeys? Were they hippopotami? Were they deer? Were they foxes? Were they birds? Were they reptiles? Were they fish? Were they insects? Were they microscopic organisms that could not see through fleshly eyeballs? Were they ice? Were they earth? Were they smoke? Were they meteorites? Were they rubbish? Were they blood? Were they bones? Were they sky? Were they outer space? What is the genesis of life? Where is the genesis of life?

While this is an endless question such as to make one lose consciousness, at the same time it is also an utterly simple discussion.

If you think through such matters of interest as birth and extinction,

eventually you will encounter nothingness and the realm of infinities.

I think that the *foolish* will to get away from such absolute sophistication as nothingness and the realm of infinities is the emergence of life.

The *foolish* will not even to be bound by immense truths such as nothingness and the realm of infinities is 'strong action' and 'energetic voice.'

Now, the sounds I make in this world are the emergence of life. Now, the beginning of life is experiencing the future.

Now, the 'strong action' and 'energetic voice' that I emit in this world

live brilliantly without even being bound by senseless destruction or by gods.

As if processing forward in *suriashi*, they confide in abundant and thus *foolish* reality any number of times.

自分はどこからきて、どこへ行くのだろう？

人間はどこからきて、どこへ行くのだろう？

生命はどこからきて、どこへ行くのだろう？

そもそも生命って何だろう？

生まれたこと、今、生きていること、成長すること、

移動すること、老いること、死ぬこと、死んだ後のこと、

生まれる前のこと、人間の祖先は何なのか？祖先の祖先は何なのか？

その祖先の祖先の祖先の祖先の祖先の祖先の祖先の祖先は何なのか？

猿なのか？カバなのか？鹿なのか？キツネなのか？鳥なのか？は虫類なのか？

魚なのか？虫なのか？肉眼では見ることのできない微生物なのか？水なのか？

土なのか？煙なのか？隕石なのか？塵なのか？血なのか？骨なのか？

空なのか？宇宙なのか？生命の起源は何なのか？生命の起源はどこにあるのか？

気の遠くなるような果てしない疑問であるが、同時にまったく単純な話でもある。

生命の誕生や消滅という関心ごとを考え抜いていくと、

いつかは無限の世界や無に出会うことになる。

無限の世界や無という絶対的な洗練から抜け出そうとするマヌケな意思を

生命の起源だと考える。

無限の世界や無という途方も無い真理にも束縛されようとしないマヌケな意思とは

「たくましい行動」や「元気な声」のことだ。

今、私がこの世界で立てている音は生命の起源だ。今、生命の原点が未来を経験している。

今、私がこの世界で発している「たくましい行動」や「元気な声」は、

無意味な破壊にも神様にも束縛されることなく立派に生きている。

すり足で進んで行くように、豊潤でマヌケな現実と何回でも打ち解け合って。

Yoshinori Henguchi

Poet, Photographer
Born July 26, 1973 in Osaka, Japan
2000: Poetry debut in poetry magazine *Wasteland*.
2001: Designed, published and crafted *The Sport Metal of Invertebrates*.
2006: Winner, Canon Corporation New Cosmos of Photography Award.
2010: Founded the *Kurome Garo* (Gallery Iris) in Osaka, Japan. Opened Gallery
Iris with over 250 successive talk sessions, readings and exhibitions.
Published the poetry collection *WMMWWMWWWMWMMWMWW* with the imprint
nobodyhurts.
2011: Guest performer at the Dusseldorf Art Expo Exhibit ANTI FOTO in 2011.

辺口芳典

写真家、詩人。
1973 年 7 月 26 日大阪生まれ
2000 年：Wasteland 誌にて作家デビュー。
2001 年：自主制作本「無脊椎動物のスポーツ・メタル」を発行。
2006 年：キヤノン写真新世紀優秀賞を受賞。
2010 年：大阪にて「黒目画廊」の運営開始。「黒目画廊」では年間 250 回を超える
トーク・セッション×朗読ギグや個展を立て続けに開催。
nobodyhurts から「女男男女女男女女女男女男男女男女男女」を出版。
2011 年：ドイツ、デュッセルドルフのゲストに選ばれ「ANTI FOTO」展に参加。